HOW TO CUT PHOTO COSTS

218 WAYS TO SPEND LESS AND GET MORE CAMERA EQUIPMENT, SUPPLIES AND SERVICES

MCI Publishing

Copyright © 1984 by Robert McQuilkin
All rights reserved

MCI Publishing
Box 162
Winfield, Illinois 60190

Printed in the United States of America
Second edition
ISBN 0-911445-00

C•O•N•T•E•N•T•S

Acknowledgements i

A Note From the Author
 (About the Readers) iii

User Advice vii

1. Best Deals First 1

2 Film for Less 23

3. Commercial Processing Breaks 39

4 Equipment Economy 55

5. Battery Savers 77

6. Extending Your Warranty 87

7. Darkroom Discounts 105

8. Camera Modifications 137

9. Fifty-Four More Ways 155

Notes From the Readers
 (About the Author) 183

Index 185

Directory of Companies 187

Acknowledgements

No one ever reads the acknowledgment page. That is, unless they expect to find their own name. And usually even then, the effort only amounts to a quick scan in search of that major attraction — no doubt looking for lies. So for those who don't care what my grandmother did to help out or who fear I might divulge too much about their contribution, relax. I'll but point a finger.

I'd like to publicly acknowledge these special people, who all know what they did but may not know the extent of their assistance — or my gratitude. To you I bow: Paul Harris, Gary Murakami, Phil Murdy, Paul Castle, Ramon Orellana, John Wilkinson, Sara Elder, David McQuilkin, Chuck Davis, Nate Young, and Susan. Oh yes, and grandma. Without your help this could not be what it is.

I suppose I should also mention (though not in any way applaud) the indomitable spirit of this book. I have no idea where it came from, but when I discovered it could not easily be disposed, I gave it ink, my name, and my blessing and sent it into the world. I prayed the little bastard would not return to haunt me. I'm still on my knees.

Note from the Author
(About the Readers)

When any ordinary baby becomes a monster, be it human or something equally terrifying as a book, the responsible parent begins to ponder the implications of its conception. This lusty infant you're staring in the face, I can assure you, began as the most innocent of thoughts. And before it was delivered into the world one cloudy spring day by the Whitehall Printing Company I attempted all manner of abortion. It lived on.

And despite my grudge, by the time it outgrew my plans and my patience, it had brought considerable amusement. The idea was to keep it in the family — self-publish — to get it out and be done with it. But the book made quick friends and introduced me to a delightfully eclectic world of photographers along the way.

At first I opened all the mail. I thought that would be a good way to keep track of the checks. If there were any, that is. Once I opened an envelope only to find a note with no check from a fellow named Bud Thies. I wrote back, "Dear Mr.

Thieves, What happened to the money?" He promptly sent in his check with the note, "I was just trying to cut my photo costs."

Never would I have considered myself superstitious until the day I drew a letter from the Church of Jesus Christ of the Latter-Day Saints containing a blank check. However, my temptation to abuse their faith was abandoned abruptly upon shelling the next letter and finding an order from Jesus, who apparently felt no obligation to include any check at all. He did leave an address, though (Miami), where I wasted no time sending an autographed copy. Understandably. But by the time I picked up the third envelope stamped with "Pleas E. Parrish" I was ready to believe it could just as well be a death wish as someone's name.

Even on average days not-so-average names surfaced, like Joe D. Dollar or a week later W. H. Saver, who naturally couldn't resist this frugal title. But the names of towns to which I mailed books — often in disbelief — brought more regular entertainment: Rocky Comfort, Missouri; Ozone, Arkansas; Sweet Home, Oregon; and I kid you not, Toad Suck Ferry, Arkansas.

We shipped books to doctors, lawyers, police officers, preachers (lots of them — they're always eager to save I guess), a historical museum (I told them it had only been out a month), the U.S. Defense Department, a garbage dump, and the Institute of Logopedics. When I couldn't find that one in the dictionary I decided it must be one of those schools of cult medicine. Indeed, if even the witch doctors must resort to economy these days, who can be exempt?

More ironic, though, were the folks who ordered a book about penny-pinching, then rounded the $8.95 price up to $9, evidently to simplify their bookkeeping. Not off to the best start, but then perhaps that's one reason they needed the book in

the first place (unlike the scoundrels who rounded down to $8 even, figuring I wasn't likely to bill 95 cents).

The diversity among people added to the intrigue as well. Some stuffed blank envelopes with checks and nothing more, on the assumption, I suppose, that I had only one book in that price range and would mail to the address on the check. One poor fellow didn't even have an address on his check — I'm still waiting for his irate letter.

Then there was the other extreme, like the impeccably typed letter from a guy (I think) named Isidro Acuna: "Enclosed is my personal check drawn to your credit in the amount of $7.95 for which I respectfully ask you to send to the above-indicated address the following publication produced by your firm *How to Cut Photo Costs*. This publication was mentioned as being available to the public on page 166, column 2, last paragraph of the July 1983 edition of *Popular Photography*" There was more.

You end up paying close attention to the checks, because the handwritten addresses are often — as odd as this may seem — written in Hebrew, though intended for good old American destinations. Anyway, that's how I happened to notice one guy's check with four female names after his own. Daughters, girlfriends, or — could it be — wives? Whoever they may have been, all I could figure was that he had a lot more trust in them than I'm certain I would have had under such delightful, albeit frightening, conditions.

And speaking of kinky, the only person I did not mail a book to was R. M. from Ohio who mailed me a box of naughty books for which he said he'd like to swap an "irregular" one of mine. I guess he figured dirty books for soiled books made a fair trade. I declined with, "All my books are very 'regular.'"

In the beginning I was forced to sell bound galleys, not at all by plan. My intention was to put out some feelers to test the water and ever since I've been inundated. Once the word escaped, I had to order more printings of the word-processed pages just to keep up with the demand before I had time to complete the actual book. My fear was that the simple quality would cause people to ask for refunds, but on the contrary, only two books have been returned.

One rebounded from a New York camera retailer for whom this text obviously was not intended. His disillusionment with it flattered the book.

The other came from Joe Wagner (remember that name) who said he didn't like certain parts of the book. He listed them. Unfortunately, his complaints were valid, and since he sounded so informed I sent him a refund check and offered to pay him more if he'd send me another hate letter, only longer. He was kind (or greedy) enough to oblige, so between the two of us I hope we've cleaned the bloopers out of this edition. If the truth be known, although that's a true story too, we had a panel of experts fact check the text last time around. But they're a gloomy bunch, in whom I found no humor to expose.

Now I realize at this point it's too late, but I hope my admission of these returns has not broken the spell. Please do not return your book for any reason. I don't want it back. But if you must, try to be witty about it.

In the end, all good things, like sex, babies, and books, no matter how marvelous at first, lose their appeal with overdosage. Too soon I realized my swelling brainchild had to be let go. Turning it over to new hands felt all the world like giving a favorite child up for adoption. The only twist — this time the kid pays *me* alimony.

User Advice

Photography, like any bad habit, thrives under indulgence. The more you feed it the more it takes to satisfy, and the ongoing expense only gets worse as you get better. Traditionally, photographers (and gluttons) have simply looked the other way and kept loading up. But the never-ending, ever-increasing costs of photography are getting harder to swallow by the day.

Regardless, according to the latest Wolfman Report, Americans still spend $30 million a day satiating their photographic appetites. It seems the only sure way to quit spending is to quit shooting — obviously a dead-end concept for amateurs and pros alike. So for those who can't live without it or who make a living with it, cheer up, relief is but a page away.

Think of it this way. If you spend as little as $20 a week on photo-related products, finishing this book will put $500 in your pocket before the year is out. Well, I can't promise that, but I'll give my word that it can at least show you where to buy the same things for half the price. Consequently, the more you spend the more you'll save. But enough of this

post-purchase sales incentive. I'll let the contents of the book prove its own justification . . . or condemnation.

Now, for a few things you can expect (and a lot you can't). First, don't look for miracle tactics. There aren't any. What you will find are practical, simple, common-sense measures compiled into a single volume. I attempted to outline and categorize all the basic methods and unique techniques of cost reduction that I've been able to finagle from pros, associates, fanatics, and from experience through my years as a staff and contract photographer with national magazine and book publishers.

Some suggestions cover elementary methods of economy for the uninformed, like bulk loading to more than halve film costs. The book goes on to include tips that have never been in print before and tricks of the trade used by professionals, like four ways to protect original transparency film submitted for publication. My suggestion is to skim the headings and skip the familiar.

And be reasonable. In an attempt to keep material as informative and useful as possible I included names, addresses, phone numbers, and even prices. I thought that would endear me. Never would I have imagined the torment it could bring to readers, and directly thereafter to me. You wouldn't believe (or maybe you would) some of the letters I received: "Personal. Attention Mr. McWaklin: I sent my 50 cents to the Dimwitt Developers in Delaware and it was returned with no forwarding address. I hope the rest of your advice is not phony."

Have a heart. Phone numbers and addresses change — hastily — in this transient society. People move on whims, they switch numbers without excuse, sometimes they die, and frequently they go out of business, particularly those listed in this book. That's why they're here, because they don't

charge enough to stay alive in the first place.

If you view figures by way of comparison and use them as a guide, not as an order form, you'll swear by the book, not at it. Then when you see something of interest, write or call and ask for more information and an updated price sheet. If they don't answer in a few days, by all means rip the page out, go kick your dog, contemplate suicide, but don't write to me. I probably know about it anyway (due to another disrespectful reader).

On the other hand, if you think you know a better way of doing something mentioned in the book, do write. I may even write back, and if it's good enough to include in the next edition I'll send you a complimentary copy when it appears. Which brings up another point (disclaimer). This text is not meant to be a consumer testing medium. My mentioning any product or tactic does not endorse it. Granted I've used most of the methods with varying degrees of success, I invented a few (and stole several), and I've purchased from most of the outlets. But I also took recommendations, quotes, and advice from other qualified sources in the field. The whole point of the book is to compile a list, the bigger the better. Use what works for you and dispose of the rest.

Then, too, I hope that such a reading will trigger your own knowledge and experience to pool the shared information and arrive at success by the route of least resistance.

But beware. Habits are easier to start than stop, which isn't to say they are all bad. Trimming photo costs is a great example of a "good" habit because it can put more food on your table, which can lead to a very "bad" habit — gluttony.

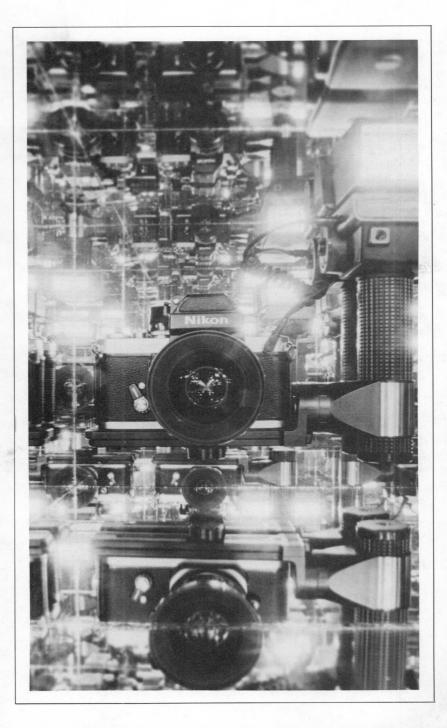

1

Best Deals First

First, an excuse for the apparent lack of organization in this chapter (not to be found elsewhere in the book, mind you): It is simply a hodgepodge of ideas inappropriate for the standard categories. Or — as the more discerning readers may detect — things I forgot to otherwise mention . However, to have listed them in the back of the book would only resemble a sloppy afterthought, whereas putting them up front appears to be as deliberate and calculating as eating dessert first. Enjoy.

My single intention is this: to beat the system. Nothing more.

Camera Enemas

Forgive that untimely transition, but this was the first item on my list (honest), and when it happened to come out this way I figured better to keep going than make an issue of it. Anyway, here's the tip: Instead of lugging around compressed air canisters

that are expensive and heavy and run out of air, try using a baby enema syringe for blowing out camera interiors and the like. They cost about a dollar, are compact and resilient, and last forever. Never mind the comments you'll get while making use of the device.

When you need more oomph for cleaning ornery negatives, enlarger heads and such, try using an empty 16-ounce squeeze bottle. A clean shampoo or soap dispenser with a nozzle-type cap works fine. They generate blasts rivaling those of Dust-Off cans but don't emit liquid oxygen when used at odd angles. Best of all they never run out of grunt.

They cost about a dollar, and last forever. Never mind the comments you'll get while making use of the device.

Mount Board Giveaway (Almost)

Try this. Write to Light Impressions at Box 940, Rochester, New York 14603, and tell them you've heard some fine gossip about their archival mount board (you just did), and that you could sure use some of it. For a while they sent free sample boxes of multishaded, museum-quality, 100 percent rag board. But we kept ordering so much of it that now they charge $2, which is still a steal.

85% Discount on Studio Umbrellas

Neither Joe Wagner (don't blame me if you don't remember him) nor I can figure out why photographers go out and spend $85 on a Reflectosol umbrella when the same thing can be had at K-mart in the rainy-day department for $5. These umbrellas look the same and reflect the same, and if you hack-

saw the handle off they even fit the same clamp. If you need gold or silver why not just buy the replacement fabric and switch?

Eternal Light

Getting tired of changing your darkroom safelights when they burn out? Install a few Buttons and you'll never need to change them again, or for that matter, ever bother to turn them off. Using this device, any lightbulb from 25 to 400 watts is guaranteed to last 75,000 hours, which amounts to say 24 hours a day for ten years straight. Essentially the easy-to-install Button (it attaches to the base of the bulb) is a solid-state half-wave rectifier that converts alternating current to pulsating current, thereby reducing electrical consumption. Conserve bulbs and bills with a six-pack of Buttons (about $2 each) from Amoco Merchandise Center, 12755 State Highway 55, Minneapolis, Minnesota 55441. Ask for product 688-714-5. Similar products are offered in many mail-order catalogs as well.

Finding Fresh Batteries (Isn't Easy)

About the only thing worse than having batteries quit in the middle of a job is having them do so a week after you buy them. Batteries can, and do, waste away while waiting on the shelf, just like milk or meat or any other perishable. But for some reason no one bothers to date batteries except Duracell, and even they camouflage the figures to ward off public inspection.

Here's how to crack the code: Imprinted on the

back of every package you will find a series of fig-
ures. The first digit stands for the last number in the
year of its manufacture. The next character is a let-
ter signifying the month it was produced and coin-
cides chronologically A–L. The following two num-
bers specify the day, and the last indicates the plant
that produced it, usually C, D, or X. Thus, a bat-
tery with 1-B-22-C was produced on February 22,
1981. Better leave that one for the next buyer.

$1 Lens Tissue

Although at first glance this may seem like squan-
dering good sense and good money, in a pinch it
may save some priceless pictures. Next time you're
caught with a dirty lens and no lens tissue, try using
an old dollar bill. That's right, good old U.S. cur-
rency has a high enough silk content that it won't
leave lint like eyeglass, facial, or toilet tissue, nor
does it scratch the polished lens element like a dirty
shirttail surely will. What's more, unlike lens tissue,
when you finish cleaning with a bill you can always
spend it.

Just Justice

Next time you do something bad in the eye of the
law, or you think you're the victim, don't forget this
number: 202/466-6313. It will connect you with a
group of high-powered attorneys who specialize in
journalistic legalities. They're already on your side
and they won't charge you by the minute. In fact,
they won't even charge at all. You'll have reached
the Hot Law Line manned 24 hours a day by the

Extravagant lens tissue? Or a reasonable emergency substitute?

Freedom of Information Center in Washington.

If you were exceedingly naughty (and poor) you may want to try this number, which belongs to the Volunteer Lawyers for the Arts: 212/575-1150. They also have branches in most major cities. But please don't cry wolf, unless you have one on your tail and he's halfway through your Fruit-of-the-Looms, lest we all lose our shorts.

Pssst, You Wanna Free Light Table?

Ever need a six-foot light table to sort through several dozen boxes of slides at once? Ever notice that huge light that does nothing but play "sun" over "her" plants downstairs? Did you ever realize how easy it is to flip upside down, especially if it is sus-

You'll never need to change them again, or even bother to turn them off.

pended by four chains from each corner (or converted to such an arrangement)? And have you ever experienced the wrath of a woman coming up from behind? So be stealthy about it, huh?

Double Loading

You can develop two rolls in half the chemistry, time, and tank space.

Here's an easy trick, and a scary one too, that will save more than just money. Whenever you have two or more rolls of film to process at the same time, place them together back to back (emulsion side facing out) and roll them onto one reel as if they were a single strip of film. You can develop two rolls in half the chemistry, time, and tank space they would otherwise take.

If this sounds risky, which it's not, you can reduce the chance of mismatching by pairing the films in daylight and taping the leaders together in proper orientation before killing the lights and loading up. It works, I've tried it. Well, once anyway. And don't raise your eyebrows at me — I didn't come up with the idea. Our hero, W. Eugene Smith, started the whole thing, and no one ever ragged him about it.

Soup In Sewer Pipe

On those rare occasions when you have 20 or 30 rolls of film to process at once, when double-rolling might not even help, don't spend a fortune on large stainless steel tanks or waste time doing them all piecemeal. Just make a tank to match your need from four-inch plastic PVC pipe carried in most hardware stores. Nearly any saw will cut the stuff; it

takes 18 inches of pipe for every ten reels. Cement an end cap on one side and use a standard tank-top lid for the other. Only one precaution: Make sure you buy black pipe rather than the typical white. Four rolls or 44 rolls, the whole deal should cost less than $5 and save more than $50, to say nothing of the convenience.

This Camera Clamp Sucks

The Gripper, made by Jim Anderson Enterprises, Box 10024, Portland, Oregon 97210, is a suction-cup affair that attaches cameras, lights, or other gear to smooth vertical surfaces such as glass or metal. A worthwhile idea, the camera bracket reportedly has an attaching pressure of 300 pounds, but at $38.25 apiece I'd say it's rather the price-tag that sucks.

Sidestep that one by visiting your local glass shop and purchasing a couple of suction-cup handles used to move large panes of glass. Attach a standard ball-joint panhead and you can have your sucker without being one too. (Sorry.)

Spaced Out

Buy a space blanket. (Yes the thought did occur to me about "having your space blanket without being spacey," but I'll not stoop.) Nevertheless, one of those large sheets of silver Mylar should be in every sensible photographer's gadget bag. The compressible yet highly reflective surface can act as a bounce-light surface or sunshade while shooting, a sun shield for unused equipment and film, protec-

tion for gear in the rain or for the photographer in snow. Consequently the versatile blanket makes more sense than it costs.

Instant Incident Light Meter

**Why not
steal
the
silver
first?**

High-contrast lighting can be maddening for reflective light meters, or for photographers using them. Incident meters, on the other hand, operate on the principle of taking all the disparate light levels, mixing them up together, and giving one reading that tends to be more accurate in contrasty conditions. An easy way to convert any reflective meter (used in nearly all modern cameras) to incident capability is to place a white foam coffee cup over the lens (in the case of SLRs) or over the meter cell. Meter readings taken through the cup will approximate gray-card reflection. Conversion cost: about two cents, unless you "borrow" the cup.

Camera Rustlers and Hustlers

I'm not sure what constitutes "illegal imports" of cameras or even why they need to be smuggled, but I am sure that photo equipment confiscated by U.S. Customs and subsequently auctioned off can be purchased at prices that *seem* unlawful. SBI Research offers a report explaining how to locate such sales and here's how they introduce it: "Did you know that photographic equipment of all types and categories is frequently included in sales of government surplus property; that U.S. Customs Service sells confiscated property including camera equipment; that many of the items are in new or near-

new condition; that surplus can be purchased at a fraction of the government's original cost? Did you also know that it is possible for you to receive free government surplus sale catalogs listing any category of property?" Our benevolent government also buys and makes its own photographic equipment and then turns around and sells it at prices so low you'll begin to understand the makings of the national deficit. The $2 booklet *How To Buy Surplus* from SBI Research, Public Department, Box 21491, Seattle, Washington 98111, leaks the scoop.

Or you can get free literature on the government's product waste straight from the donkey's mouth by writing to the Federal Information Center, General Services Administration, Washington, D.C. 20405, or ask them for an address near you.

U.S. Customs sells so low you'll understand the makings of the national deficit.

Those photographers too impatient (or "busy" if you prefer) to wait around for the auctions can buy surplus and contraband directly from the Image Warehouse, which buys up the leftover photo supplies at auctions and sells directly to the consumer at prices that would embarrass the Defense Department if it knew. For instance, here are some items available at the time of this writing: several $12,000 Pako CTX Processors for $2,400 each, a government KS7 Princeton vertical-horizontal process-copy camera with 9- and 10-inch lenses for $395, government auto-enlarger up to 5-inch roll film worth $10,000 for $495, a portable darkroom for $99, 8×10 film holders for $3.50, and Kodak sound movie decks at $39. For current catalog write to Image Warehouse, 6225 Tara Boulevard, Jonesboro, Georgia 30236, 404/991-0071.

Conversely, photographers who dream about auctions will have to pinch themselves to believe this one: Every Sunday from 9 a.m. to 2 p.m. lensmen gather at the Alameda Hotel, 2540 Santa Clara Avenue, Alameda, California 94501, and swap up a storm. Outright hawking, buying for cash, trading

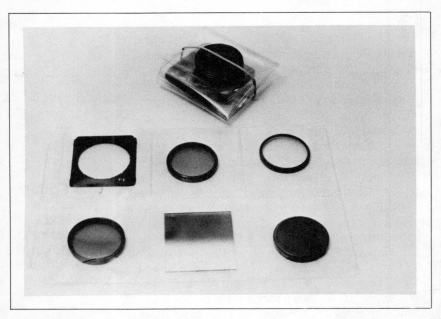

Some innovations, like plastic slide pages used as filter holders, cost 25 cents to incorporate but will save 25 minutes with every use.

even-steven, and just about any swapping short of swiping is sanctioned and carried on with vigor. Get in the action — er, auction — by calling Fred Long at 415/522-3336 or 521-2177.

Don't miss out on the local hustles either. You'd be surprised at how many camera stores have taken up the trading practice. For instance, Lion Photo in Villa Park, Illinois, hosts periodic "Midnight Madness Sales," riotous occasions where everything in the store is reduced and patrons can buy and sell to or from each other and the store until midnight.

Another Chicago-area store, Darkroom Aids, ran this ad for their last Dutch auction: "All items in this section will appear each month at 10 percent less than the previous month until sold. But don't

Just about any swapping short of swiping is sanctioned.

be too greedy by waiting too long — you may lose the item you're waiting for." Check for similar shenanigans in your area, and if there are none, suggest them.

One other alternative to purchasing new retail camera gear is provided by the national trade paper called *Shutterbug Ads*, which lists thousands of pieces of used photographic equipment every month at prices that won't cramp your wallet but may cramp your neck with double-takes. Witness Nikon Ftn's for $69 and up by the hundreds. The hundred-page, large-format tabloid categorizes everything (meaning just about every photographic device ever made) into 70 different sections, and the subscription price is well worth the $10 just to learn what can be had for so little. You can test six issues for $6 by writing to *Shutterbug Ads*, Box F-840, Titusville, Florida 32780.

Quick Silver

Extracting silver from halides left behind in developer is such a natural topic for this book I decided there was no point in belaboring it. Besides, everyone is already into that (if you're not, quick, read Chapter 7). But ironically most photographers toss more silver than they save by throwing out unwanted prints, slides, and negatives. Why not steal the silver from them first and then just scrap the paper and plastic base? Pull off the heist by soaking everything in a tub of bleach once a year, then extract the silver by conventional means. At $14 an ounce, it won't take much silver recovery from your waste materials to pay for the extraction system, and from then on it's pure gravy — er, bullion.

Filter Files

Carrying around filters has always been a dilemma.
The usual stack-'em-up-and-screw-'em-together
technique works fine until you need to find one, let
alone use it. An easy and inexpensive solution to
keep filters covered, compact, and convenient is to
sheeth them in pockets on a polyvinyl page intend-
ed for 2¼ slides folding each layer inward at the
seam.

Sleep Cheap

Photographers who travel a lot, or even once, could
benefit from this publication: *Budget Motels Direc-
tory*, which lists 2,200 motels in the U.S. and Can-
ada with doubles for $18 to $28 and singles for less.
Pilot Books, 103 Cooper Street, Babylon, New
York 11702.

 If that's still too high for your taste, this book
may help: *Free Campgrounds, U.S.A.*, VanMeer
Publications, Box 1289, Clearwater, Florida 33517.

Books With High-Yield Return

While I'm bragging about other books, hoping of
course that it might encourage reciprocal good will,
I might as well mention these two. *How To Shrink
Your Phone Bill* (Ballantine) costs only $1.95 but
promises "dozens of ways to save hundreds of dol-
lars." One of the many tips includes a way to lower
the cost of long-distance calls 60 percent by using
special methods the phone company won't tell you

about. Written by Howard Strange, no stranger to
Mother Bell, or friend either, having served as re-
search associate for the Subcommittee on Anti-
Trust Monopoly to the Senate, investigating mo-
nopolistic practices in the telephone industry. You
can trust him.

Spend $2 to save $600.

Then there's this one: *No-Cost, Low-Cost En-
ergy Tips* for the same price (I just don't know how
they do it), by Bantam Books. It promises 52 ways
to save $1,000 a year in your darkroom energy
costs. For instance, straight from the contents:
spend $1 on the furnace and save $50 a year; spend
30 cents on the shower (if your darkroom has one)
and save $40 per year; spend ten minutes with the
heating systems and save $200; spend $40 on doors
and windows and save $150 every year thereafter;
spend ten minutes a month on the car (another ex-
travagent darkroom accessory) and save $200;
spend $25 fooling your thermostat and save $100 a
year. So spend $2 for Pete's sake, or at least for your
own sake, and save the $600 I just promised.

Steal Shower Curtain for Cheap View

Not that you'd care to show pictures while shower-
ing, but swiping the shower curtain liner when you
finish can make for great rear-screen projection.
(No wild ideas please, "rear-screen projection" is
simply when the projector is aimed from behind the
screen rather than in front.) Anyway, the idea is to
sew a rod into each end of the curtain so it can hang
straight between projector and audience, suspend-
ed by the upper dowel. Of course that's not to say
that making use of the tactic might not consequent-
ly result in a pretty decent (or rather indecent)
show back at the shower, too. Now where was I?

Oh yes, shower curtain liners for perfect rear projection. And if you thought that was objectionable, take a peek at the price tag on commercial rear-projection screens.

Now wait. Before you toss that old silver projection screen consider this: They make first-rate reflectors for studio strobes or tungsten lights indoors or for bounce fill-light outside. They don't even require a stand or frame. And one more thing: Don't dispose of anything else either until you finish the rest of this book. For instance:

Wasted Wipers

When your windshield wipers wear out don't throw them away. Attach a handle from a paintbrush roller and presto: a print squeegee good for prints up to 11×14 inches . . . unless you drive a semi truck.

Disposable Cameras

The Pampers people started it all and now we have disposable dishes, razors, tents, and satellites. The latest to debut, as you know, is the disposable camera, and to my mind it makes a lot of sense. Many photographers get wasteful by taking $300 cameras where they shouldn't and coming home with scrap metal. That's where a disposable camera comes in handy — use it and pitch it. And at $7.95 for the manual 35mm Beirette complete with a leather case and 45mm 2.8 lens, how can you go wrong? At least that's what I paid for mine, though I understand it can be had for less (and more) depending on the

I had to include this picture so you wouldn't think I was lying. Well, what do you expect for $7?

quantity purchased and the number of middlemen taking tips along the way.

Such cameras are made to abuse and lose without remorse. If you can't find any in your area try asking Hanimex (the distributor), who won't sell you any but might tell you where to find the best deals: 1801 Touhy Avenue, Elk Grove Village, Illinois 60007. Then again such a disclosure may infuriate them since many of the dealers are marking the camera up to $39.95. If you get nowhere with them try Lion Photo in Aurora, Illinois, which has a stack of the cameras and I'm certain would make a sweet deal if you ask. Should all else fail and you *must* have one, write to me and I'll see what I can do. No, you can't have my number.

Such a disclosure may infuriate them since many of the dealers mark the camera up 500 percent.

Film for 30 Cents

Now I see I've backed myself into a corner of logic. No one in his right mind would want to pay more for a roll of film than for an entire camera. Witness the current cost of Ektachrome 400. So here is something to rival the price of the Beirette: any film for 30 cents a roll. Now face it, at a price like that you can't expect a straight over-the-counter purchase. My understanding is that it involves some sort of pyramid-type marketing/buying, but in the end you do get your film for the promised price. Find out more from Roger Boly, 1646 Jones Street, Glendale Heights, Illinois 60137, 312/260-1558.

Trade Your Camera for a Condo

Anytime you don't have something you want, or do have something you don't want, trade it. According to a recent study by Baruch College in New York City, this shifty little pastime accounts for more than $300 billion a year in lost taxes the Internal Revenue Service would like to believe belongs to them. It's always been a cinch for, say, a dentist to fix up a carpenter's mouth in exchange for home repairs, whereas traditionally photographers have not always had such a handy access to potential traders.

Now they do via the National Exchange Directory that offers two-week condo/chalet exchanges in Colorado, Switzerland, or Australia. You can also exchange computers, cameras, boats, office space, days off from work, advertising, and the like for nearly any conceivable item — as well as a few inconceivable ones. For $3 a month members receive the newsletter, a free 20-word personal ad, and a $14 book called *How To Buy Without Cash*

for $10. Write to Let's Trade, Box 152, Miami Springs, Florida 33166. I'll bet you can even trade that book for something if you try.

Spit in Your Spotone

Every so often you run across a stubborn print that won't take spotting — usually the result of insufficient wash time. Next time your Spotone won't take, spit in it. Saliva mixed with Spotone (preferably not in the mouth) will help the dye adhere to glossy surfaces.

If That Doesn't Work Try Alka-Seltzer

Just for the sake of discussion let's say you get sloppy with your spitting and spotting and mess up the print. Usually there is no recourse for the indelible dye, but here's one solution — straight from the folks who are famous for undoing what people with uncontrollable mouths bring on themselves. A tablet of Alka-Seltzer, the kind in the blue box, dissolved in eight ounces of water, will erase your runaway brush strokes.

Here's a way to make 60 × 80-inch prints in less than one gallon of chemistry.

Rubber Masking

The problem with modifying color prints with dyes or monochrome prints with bleach is that it's difficult to contain the process within a local area. Various print masking materials are available and ex-

pensive, but the more immediate drawback is not having any when you need it. Something you are likely to have on hand that costs a fraction of equivalents like Photo Maskoid but performs as well is ordinary rubber cement. Simply brush it on the desired area and rub it off when you're through.

Cutting the Static

Next time your camera gives you static, particularly in cold, dry conditions, squirt the little brat with a spray can of Singh-Ray Anti-Static Compound CX-3B, available only through Optivision, 9210 W. Peoria Avenue, Peoria, Arizona 85345, 602/979-4661. Spraying the interior of the camera will alleviate problems of static, and while you have it in hand, mist the interior of your camera bag, enlarger, and other objects you wish to shed dust. The compound causes dust to be repelled like insects from Raid.

Conversion cost: about two cents, unless you "borrow" the cup.

Pig Troughs for Big Prints

Here's a way to enlarge 60×80-inch prints in less than a gallon of chemistry and a foot of floor space. Instead of trying to make giant trays and fill them with barrels of solutions, just use pig-feeding troughs available at Sears or hardware and farm-supply stores. Troughs come in a variety of lengths: The four-inch wide version works perfectly.

To make use of them have an assistant hold the upper edge of the print above the tray while you dip the lower edge in the solution. Run it across the

bottom and out the other side. By raising and lowering each side alternately the print receives adequate chemical contact and agitation for proper development. Arrange three trays (developer, stop bath, and fixer) beside each other and simply dip into each consecutively. For smaller prints, say 30×40 or less, use wallpaper-hanging trays sold at paint stores for considerably less than the galvanized hog trays.

The whole deal should cost less than $5 and save more than $50.

Free Advice

When you have questions concerning any type of Polaroid product, free consultation with a technical representative is available by dialing 800/225-1618. The call won't even cost.

In fact, anytime you have any question at all, see if the company has a toll-free number first by checking it at 800/555-1212, which of course is toll-free.

Outdated Paper at Outdated Prices

If you don't act, and act now, you'll lose out on one of the greatest savings enlarging paper will ever see. We all know paper doesn't really expire — it just slows down. Kodak and other manufacturers know it too but have only recently come to their senses and discontinued the practice of dating boxes. So while they last, boxes with dates are selling like rarities. In fact, they are. Ask your local dealer if you can buy his outdated paper and he'll either say "Sure, how much do you want?" or "What are you talking about, they don't date paper anymore."

A Simple Twist

One expense that large format camera users must contend with is the cost of huge filters to cover the front lens element. Fracture the cost but not the quality by adapting filters for the smaller rear lens element.

The prices won't cramp your wallet but may cramp your neck with double-takes.

Two-Cent Filters

Buy demo equipment and other closeout items from Photo Imports, Camera Warehouse No. 5, Box 87, Bronxville, New York 10708. Their free *Closeout Bulletin* lists filters for two cents, sunshades for a quarter, and Nikons, Canons, Minoltas, flash equipment, lenses, and accessories, all at prices too good, or, I suppose, "bad" to be true.

The End of the Beginning

I trust that by now I have extinguished any hope of textbook logic, order, or reverence that may have been expected from this tome. And make no mistake, I have no hopes of literary awards, fellowship invitations, honorary degrees, or acclaim from the photographic community for this effort. My single intention is this: to beat the system. Nothing more.

2

Film for Less

An expense no photographer can avoid is that of film and processing — the lifeblood of this hobby — the part that never wanes and always remains beyond control. It's a bit like buying a car: You can select a model within your budget, but you can't use it without gas. So the suppliers know they have us by our tailpipes and can charge anything they please. We can't go anywhere without them, and they know we're not about to ditch our motor drives or motor cars.

The problem with photography, though, is that a roll of film can cost 10 percent of what the camera costs. By comparison, this would be like paying $1,000 for a tank of gas. I can remember when film prices rose three times in one year because of heavy speculation in silver. But when the scapegoat (the price of silver) came back to earth, film and paper prices did not. They (meaning all greedy bureaucratic film manufacturers, but one big, fat yellow one in particular) expect us to keep paying whatever they demand. However, they probably didn't

The suppliers know they have us by our tailpipes.

expect to see anything like this float into the public's hands. Read on if you're tired of bowing to the Great Yellow Father.

Rolling Your Own

Rolling your own film can bring the cost down so low you'll get high just thinking about it. Unfortunately some of the bad side effects scare off a good percentage of would-be users. Here are two ways to avoid the alleged dangers.

$30 will pay for itself in the first two rolls and from then on your film costs will be halved.

One phobia is that the practice can lead to permanent damage in the form of scratched emulsions. Yet I can think of at least a dozen other ways to scratch film. The logical solution, it would seem, is not to do away with offending objects (bulk loaders, cameras, fingers, and the like) as if they were intrinsically evil, but use them all intelligently. The "right way" with bulk loading is to limit cassette use to five loads and vac out the interior and felt gates between each roll.

Better still, skeptics and purists can purchase Nikon or Pentax cassettes equipped with mechanical gates that open inside the camera and loader, preventing the film from touching anything besides air. Initially mechanical cassettes may cost more than standard cassettes, but they're safe and they last forever. Commercial film is manufactured with felt-lined gates through which the film must pass. This system of keeping film light-tight is not, in the strictest sense, failproof because particles of dust or debris caught in the gate can scratch the emulsion during advance or rewind regardless of who did the loading.

Furthermore, when the film is returned all the way into the cassette after having been exposed,

light can leak through the felt and fog the film under certain conditions since film has the capacity to store and compound light exposure. With Nikon or Pentax cassettes the gates seal completely. In that regard, as ironic as it may sound, bulk loads are even safer than commercial loads.

The other gripe hurled at bulk loaders is that the exposed end of the film could ruin the last few frames. Resolve that by loading the film in a darkroom or in the dark.

Getting Loaded

Now that we've come this far I must make a slight digression on the chance that some readers have never even heard of loading their own. Film that is. Essentially this is it: Many types of films are sold in long rolls (100 feet or more) at considerable cost reduction, to the tune of nearly half price. At this time one roll of 36-exposure Ektachrome sells for $4.56. That same film bought in bulk comes out to $2.76 per 36-exposure roll.

So the financial savings are obvious, but several additional benefits await those who load their own film. Roll lengths can be customized from two exposures to 52 exposures on one cassette. And film is always at hand. You stand less risk of running out when you need another roll and can't get one — on vacation or on holidays.

The initial expense of the loader ranges from $8 to $25, depending on the name and quality of the loader. Individual cassettes (the spools and canisters that hold the film) are available in three varieties: Snap Caps from Kodak, plastic screw-on caps, and metal cassettes with positive-locking ends. I'd advise using the latter type with concave lips be-

cause they are more secure. Security means that when you've shot a priceless roll of film you don't have to worry about the end popping off if you happen to drop it once. These cassettes run about 35 cents apiece and claim reusability of ten to 20 times, though I'm not saying I'd encourage that many reruns.

Still, a maximum outlay of $30 will pay for itself in the first two 100-foot rolls you use, and from then on your film costs will be halved.

Bulk-Loading Bull

Although I've never heard of any photographer who could roll his own film with one hand, it is nevertheless a simple process that takes approximately two minutes. If you don't know how, someone at your local photo supply store will be thrilled to show you, particularly if you let him supply the stuff. Or of course you could always read the instruction sheet.

Bulk film can be purchased in various lengths: 27¼-. 50-, 100-foot, or longer rolls. And believe me that's nothing. Kodak makes film in eight-foot-wide strips that goes on for miles before it's whacked up and stuffed into little yellow cans. Of course, the longer the roll the greater the savings, but you can expect to get between 18 and 20 36-exposure rolls from 100 feet, depending on how miserly you are with the leader length on each roll.

Cheap Cassettes

One dubious way to purchase a large number of inexpensive cassettes for bulk loading is through your

local newspaper. Many newspapers will only use cassettes a maximum number of times and then discard them or try to pawn them off at local photo shops. If you happen to be their source of disposal, you'll get first pick for a fraction of the commercial price with quite a few uses left per cassette.

Cheaper Cassettes

If that doesn't work you can buy new ones for 24 cents each in lots of 100 from Eldee Sales, Box 29, Peabody, Massachusetts 01960.

Some have never even heard of loading their own.

Cheapest Cassettes

Then, of course, there are the freebies. Those guys who snub their noses at bulk loading in preference to commercial canisters can have both for nothing. Instead of prying open commercial rolls in the darkroom with bottle openers or your teeth, simply back the film out. When you rewind the film that's in the camera, leave the leader partially exposed instead of winding it completely into the film holder, which incidentally helps prevent light leakage, discussed above while you were sleeping. Cut or tear the end off square, pull out six inches or so of film, and enter it directly onto the developing reel. Then just wind the rest of the film out of the cassette and clip it off when you reach the end. Now you have a standard cassette with a tongue of film to which you can tape the new end of your bulk film and wind away, without even having to mess around with snap caps. Imagine what our Yellow Father would think of that.

Or This — Bulk Film at 80% Discount

Imagine what our Yellow Father would think of that.

Some people are never satisfied. You tell them how to cut their film costs in half and how to get free cassettes and they want more. Okay, okay. How about bulk film at massive discounts? Here are a few current examples: 100-foot rolls of Ektachrome for $24.95. That film usually sells for $48 in bulk or, catch yourself, $92.50 individually. One-hundred-foot rolls of 16mm Ektachrome are selling for a measly $5.95. Color negative film in 200-foot rolls are going — and going fast — for $14.98. Granted these specific films may be long gone before I wade through the rest of this book, have it typeset,

Acquire free cassettes by loading film from a commercial cassette directly onto the reel, clipping it off at the end, taping bulk film onto the end tab, then reloading as usual.

pasted-up, printed, and delivered to you, but find out about the latest by writing to Fairstryk, 445 W. 50th Street, New York, New York 10019, 212/757-4755.

Film Types Save

Another practical way to cut film expenses is to make sure you are using the right film for your needs. I have heard more B.S. (bogus stories) slung about which films can do what that I fear any discussion on the topic is bound to create violent reactions somewhere outside the sanction of these pages. People go to exorbitant lengths to analyze camera equipment before it's purchased, then turn around and pick film with the whimsicality of a teenage flirt, sticking with one film for a month or two only to dump it for another one that catches their eye. They could save some heartache and cash by choosing wisely and staying loyal.

You can approach the whole thing logically by sorting out your needs, such as whether you should shoot negative or slide film. Initially negative film is about half the price of slide film, but when you include the cost of processing and printing 3×5 pictures from each frame, it could upturn the tables. Several considerations can affect your choice.

First, what is the intended use for your pictures? If all you plan to do is put them in a scrapbook, then you might have no need for slides. But if you ever plan to project them or sell them for publication, then you will need to use slide film.

Something else to ponder is how many of the pictures will you ultimately use? If you normally keep only five or ten pictures out of a 36-exposure roll to include in an album or to give away or whatever, then you are paying extra for prints to stuff

your trash can. One aid here is to have a contact print made rather than individual pictures. For $1.50 a black-and-white contact print can be made from your color negatives, and though you won't be able to view color, you should be able to pick which pictures you would like enlarged and which you have no use for. This way you end up paying only for the ones you want rather than the entire roll.

Remember, however, regardless of which film you use, prints can be made from slides and slides can be made from negatives, so don't foolishly limit yourself to one or the other.

Slides vs. Negs

The following is a list of pros and cons of slide versus negative film:

● The primary advantage of slide film is that it comes in a much larger selection of film types. With negative film only a few varieties are available. For example, Kodak offers Kodacolor VR 100, 200, 400, 1000, and Vericolor. By contrast, in slide film they make Kodachrome 25, Kodachrome 40, Kodachrome 64, Professional Kodachrome 25 and 64, Ektachrome 64, Ektachrome 100, Ektachrome 160, Ektachrome 200, Ektachrome 400, 5247 film, three tungsten films, infrared film, and various slide duping and photomicrography films, among others. So for special subjects or lighting situations, slide film might match the conditions more closely.

If the decision is too tough, 5247 film may be your out.

● Slide film displays higher contrast than negative film. Subjects with high contrast, such as sunlit water scenes or pictures with large areas of dark shadow, are better suited to negative film.

● Cibachrome prints, with intensified color and longer print life expectancy, are available from slides but not negatives.

● The development price of slides is lower than negatives and prints, although prints made from slides or negatives are identical in price.

● A large variety of positive film is made in the longer lengths, whereas only two color negative films are available in bulk rolls.

● Slides are inherently better protected than negatives, with individual frames to keep the film surface out of direct contact with other materials. Negatives are more exposed and tend to scratch or become contaminated.

● Kodachrome slide film has color dyes added to the film during processing and is a much more stable material, outlasting other color materials by decades. Most color films have been laboratory tested for periods up to 25 years without significant color shift under ideal conditions — low humidity, temperature, and light. Kodachrome, on the other hand, lasts 75 years without appreciable change.

In truth, film manufacturers give themselves leeway, and at best dates are general guidelines, not a promise that the film will curl up and wither if it reaches the terminal date on its box. But since customers tend to think it might, outdated film usually sells for equally absurd prices. Take advantage of that. To begin with films will easily outlast the indicated dates by at least a year without any special precautions. Then they can be immortalized by refrigeration. Keeping film at 40 degrees will decrease expiration to a trickle, and storing it below freezing will halt expiration permanently. So buy film in quantity or with short-lived dates and make it last forever in your fridge. Just remember to give the film three or four hours to quit shivering before you use it.

Some films can outlive their death-row dates better than others. Kodachrome, which is not sold in bulk, is one that lasts longer than most slide films because it is more or less a black-and-white film to

which color dyes are added during processing. As such it can tolerate heat and humidity, the major deterrents, without as much effect. Likewise, most black-and-white films are safe too.

So the question is where can one buy outdated film? Check with your local dealer for starters. Another place that stocks outdated film and paper is the aforementioned Fairstryk, but I won't make you go back and find it. They reside at 445 W. 50th Street, New York, New York 10019. Remember? *Shutterbug Ads* (also mentioned awhile back) frequently sells outdated film of all varieties. You'll find it, among other places in this book, at Box F-840, Titusville, Florida 32781.

Another way to make use of the refrigeration principle is to buy fresh film in large quantities from discount wholesalers and store it. Even large retail outlets will usually sell film in quantity with discounted prices. Lion Photo in Aurora, Illinois, for instance, sells any film at a 10 percent discount when five or more rolls are purchased at a time. Even through the mail.

Free Film

Alas, if the decision is too tough and you cannot choose between film types, 5247 film may be your answer. It produces both slides and negatives (and prints, too, if you like). This universal film adapted from the motion picture industry can be exposed at ASA 100, 200, or 400, with no additional charge in processing. Just tell the lab how you exposed it. If you are interested in testing this film, send 50 cents to cover postage and handling to one of these addresses: MSI Heritage Color Lab, Box 2736, Portland, Oregon 97208; Box 30730, Jamaica, New York 11430; or Box 2075, Woodland Hills, California 91364.

Once you're sold on the film, or MSI gets tired of sending you free rolls to different names at the same address, go ahead and pay them for it. You'll still save 50 percent over what you would pay elsewhere. A typical price range for their film is four 36-exposure rolls for $6 with a 10 percent discount when making an order for $24 or more. An additional 15 percent can be saved by asking for their "starter kit" of either roll film slides and negatives, roll film prints and negatives, or roll-film slides, prints, and negatives. As if that's not enough, they even agree to replace your roll of film for $1 if you let them process it. How can you err?

The film develops in water—nothing more. Honest.

But just for competition's sake, there is one other place where you can get a good deal on universal film. For $1 a roll Seattle Film Works, Box C-34056, Seattle, Washington 98124, 206/283-9074, will send you either 5247 or 5294 film. No obligations.

Film at Cost

You can buy just about any other kind of film at cost with or without mailers from D & I Camera Shoppe, Box 437, Port Huron, Michigan 48061-0437, 313/987-2854. A complete and current price list is mailed upon request, but prices do fluctuate from day to day depending on the quantity made available from "the supplier." I wonder who that might be?

A Penny a Slide

Here's a film that will convert your negatives into black-and-white positives for projection, provide

instant transparencies of flat art, and convert color slides to black-and-white negatives, all for a cent apiece. What's more, the film develops in water. Honest. Instant Image film, developed by computer companies for mass data storage, is now available for photographic use. It is exposed to ultraviolet light through the original negative and the new image develops two seconds later on the Instant Image film. No chemicals are needed, and the film does not curl, tear, or scratch.

It works something like this. First sandwich the Instant Image film with the film to be copied between two pieces of glass. Hold this up to some source of ultraviolet light like the sun or a fluorescent light. The film develops when it comes in contact with any heat source such as hot water or an iron. And that does it. An introductory kit of this remarkable film — including one 125-foot 35mm roll, slide mounts, samples of processed film, samples of unexposed Instant Image film, instructions and information, sells for $9.95 through Box 520, Maywood, California 90270. Or if we put them out of business buying too many kits try Instant Image Film, 4112 W. Commonwealth Avenue, Fullerton, California 92633, 714/526-2297, where standard 100-foot rolls sell for $15.95.

Flim Flam Film

There is just no way to please some people. They won't shoot anything but Kodachrome and they won't buy any of that unless it's sealed in factory plastic and they still want cut-rate prices. To them I'd say, best talk to Albert Moldvay, president of the Photographic Society International at 1380 Morningside Way, Venice, California 90291. Membership in this association will provide numerous

cost-saving breaks, which I'll sprinkle at appropri-
ate places in the book, the first of which is this: di-
rect-from-factory Kodachrome for $4.15 compared
to the standard $5.06. No limit.

Here is another source of possible interest to
Kodak lovers. Their films can be purchased at dis-
count prices from JMAPCO, Box 7364, Atlanta,
Georgia 30357.

The Outdoorsman at 623 E. King Street,
Boone, North Carolina, 28607, 704/262-1111, sells
film at rock-bottom prices in bulk quantity. Kodak
prepaid photoprocessing mailers are also available
at less-than-usual prices when bought in quantity
here. Postage will be paid by The Outdoorsman for
any order over $100.

*They are
by no means
the only
ones, but
they're among
the lowest
priced.*

Outdated Film

Theoretically you could get into trouble buying out-
dated or short- dated film, but when was the last
time anyone ever listened to theory? Nevertheless,
as soon as I suggest buying outdated film I'll have a
horde of sniveling by-the-bookers on my back.
Who cares? Buy the stuff anyway. I've purchased
plenty of it over the years and have never found a
bad one. I'm not saying you won't (just to keep
them happy), but I never have.

Lowest Priced Film

The following is a list of discount film outlets in the
U.S. Not that they're the only ones by any means,
but they're among the lowest priced. For instance,
Adorama sells Kodachrome 36-exposure rolls with

Kodak prepaid processing for $6.49 a roll. That same package bought from Kodak would cost $11.85 at this time. That's hard to beat no matter where you go.

Adorama
138 W. 34th Street
New York, New York 10001
800/223-2500

Focus Electronics
4523 13th Avenue
Brooklyn, New York 10010
800/221-0828 or 212/871-7600

Forty-Seventh Street Photo
67 W. 47th Street
New York, New York 10036
800/221-7774 or 212/260-4410

Garden Camera
345 Seventh Avenue
New York, New York 10001
800/223-5830 or 212/868-1424

Sharp Photo
1225 Broadway
New York, New York 10001
800/223-7633 or 212/532-1733

One Last Urge

Please use what you read about in this and other chapters or it won't do anyone any good. Let's get off our knees and kick back at the merchandising giants.

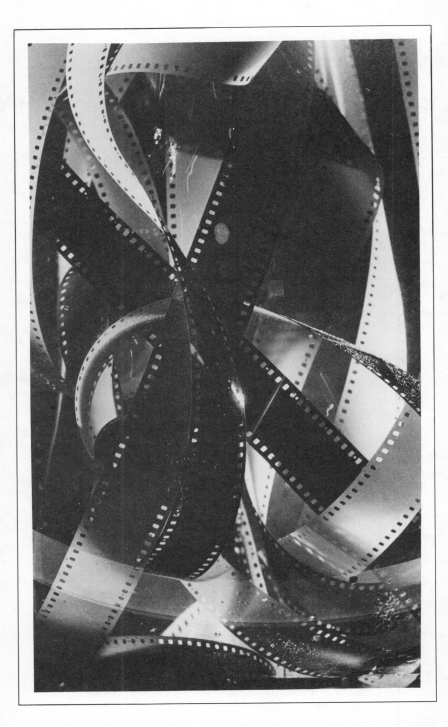

3

Commercial
Processing Breaks

The greatest misconception the average photographer has is that he thinks he must pay retail price for photofinishing. Last year 2.5 billion dollars were spent on snapshots by undiscerning shutterbugs. Does that number mean much? Look at it this way: I'm going to show how anyone can cut his processing costs in half by using a few simple tactics. Which means if we could get everyone to cooperate we could save ourselves more than a billion dollars next year just on reprints alone.

Now suppose it worked out that way and we put the wad in the bank. We photographers could be earning $100 million a year for the rest of our lives. And just how much is that? Well, you could buy an entire Leica system with five lenses and a pile of accessories every day for the next 124 years. And that's just from the uncompounded interest we'd be earning the first year on what we saved in one year.

Obviously that's not likely to occur, nor this, but just the same imagine four thousand photographers lined up shoulder-to-shoulder across the

Anyone can cut his processing costs in half by using six simple tactics.

Golden Gate Bridge, each with their brand new Leica systems. On cue they all let out a whoop and pitch everything over the edge. The following day they come out and do the same thing. And every day thereafter. Outrageous? You bet, and essentially that's what our squandering amounts to day after day in the photofinishing department. I suppose by now I've made my point, which was simply to expose the immensity of waste within our fraternity at this one level. And that "a little," a lot of times, adds up.

Begin here: Shop around and avoid the obvious traps, like drugstore drop-offs and other unphotographic photo processors. Frequently you can win favors from the local camera shop, but if you want discounts you have to ask for them. A large photo lab in the Chicago area (La Salle Photo) will offer a 10 percent discount to anyone who walks in the door with a business card. A friend of mine came back from a trip once with forty rolls of slide film and asked the manager of our local photo shop if he could have a 15 percent discount on Kodak processing because, if not, he said he knew where he could. He named the competitor. The discount was granted, which he has been exploiting ever since.

Most reasonable photo retailers will also offer discounts to local studios and other professionals due to the larger quantity of business those individuals generate. Ask to see the manager and negotiate reasonable terms. If professional discounts are offered at your local photo shop but you do not have the necessary credentials, try to arrange a deal with one of the local studios to route your work through their business. Don't tell them I sent you, though.

What matters is that you compare prices and talk business. Frequently you can beat local prices by going to a national lab that specializes in specific

areas. For instance, one of the local labs in Chicago, called Gamma, charges $12.50 for a 5×7 color enlargement. The same thing from Fast Foto in Rockledge, Florida, commands 75 cents. Here are a few more comparisons: 8×10 at Gamma — $12.50 to $24, Fast Foto — $1.70; 20×24 at Gamma — $63 to $95, Fast Foto — $15.95; Fast Foto's 3×5s are 45 cents. Sure, Gamma is a professional lab, but it gives you an idea of price fluctuation for the same service. Compare these to the prices you are used to and if you're already wiping sweat from your brow here's their full address: Fast Foto, 281 Gus Hipp Boulevard, Rockledge, Florida 32955, 305/631-5080. Oh it was Gamma you wanted? Well, they are at 314 W. Superior Street, Chicago, Illinois 60610. My, you must have it bad.

With the savings you could buy an entire Leica system with five lenses and a pile of accessories every day for the next 134 years.

Better Yet

If you thought Fast Foto prices were low — and they are — consider these from Toco: 8×10 color prints $1.50, 11×14 — $5.25; 16×20 — $8.95; 20×24 — $11.95. See what I mean? You don't have to pay what you think you might. Toco Color Labs, 3809 N. Druid Hills Road, Box 29864, Atlanta, Georgia 30359, 404/321-1217. They'll even pay your postage if you request their catalog and prepaid mailers.

More Competition

The following are some of the most economical photofinishing labs in the nation.

Capri Color
Box 831
Laredo, Texas 78040

Glo Color Labs
Box 9
Newark, New Jersey 07101

Jackson Quality Color Labs
Box 26020
San Diego, California 92126

Master Color Lab
GPO Box 30-K
Newark, New Jersey 07101

The World of 35mm
Box 2945
Patterson, New Jersey 07509

Naturally the whole idea would flop without a limit of one per customer, and dazzling results.

Free 11 × 14s (Well, Almost Anyway)

The catch, as always, is that you get the freebie when you send in two rolls of film. Nevertheless it's a nice enlargement you might not get at home so try sending them your next processing order. General Color, 604 Brevard Avenue, Box 70, Cocoa, Florida 32922, 305/631-1602. They promise 48-hour service.

Risky Business

Some photographers do not like to use mail-order labs due to the lack of security and the potential loss of originals in the mail (or simply because the mail service is an easy scapegoat for such oper-

ations). The best way to protect yourself against this possibility is to send all film by registered or insured mail with a return receipt and ask for it to be sent back the same way. Keep a copy of your correspondence. I'll say this. I've been publishing photos for a long time, which is a business that depends on the U.S. mail service. To date with thousands of photos going out every year, I have yet to lose one in the mail.

Here's a method of sending anything through express mail without paying for it.

One of these prints (originals in color) cost $90 while the other was $11.50. You be the judge.

Free U.S. Express Mail

Would you be interested in a method of sending virtually anything through express mail without paying anything for it? That's what I thought. Here's

*Pay these
prices
forever,
in defiance
of what
inflation
brings on
the rest
of us.*

what to do. Take your package to your local post office at about 4:30 p.m. and ask to send it overnight. Pay the normal fee and keep the stamped receipt. Fridays are especially effective. Regardless, your package will not arrive the next day — you can count on that — then you collect a full refund. It's perfectly dependable. Believe me, I regularly ship things free this way. In fact, I just keep a pile of stubs and trade the refund for the next shipment for which, of course, I'll collect another refund. Don't try this tactic with Federal Express, though. I use them when I need overnight delivery.

Club Discounts

I was never really certain what the primary function of camera clubs was apart from back-scratching. Maybe that's it. However, I'm quite sure of the many secondary advantages, one of which is bargains. Through their numbers they can demand deals. For instance, I can think of at least three clubs listed below that offer this book to their members for a pittance. I don't even know how they swung that one, but they did.

Clubs can generally provide more direct savings by acting as a liaison between members and local photo dealers. Willowcrest Photo of Villa Park, Illinois, though they don't broadcast it, gives members of selected camera clubs 15 percent discounts on everything in the store.

More than 4,000 camera clubs meet around the U.S., and if you want to find out the names of some near you write to the Marketing Manager, *Petersen's Photographic*, 8490 Sunset Boulevard, Los Angeles, California 90069, for a free list in your area. Or you can buy the whole list for $45 per thousand.

National clubs can't give specific information or assistance in local areas but most extend a helping hand on other levels. The Photographic Society International, 1380 Morningside Way, Venice, California 90291, offers free camera repair estimates to members, various discounts on equipment arranged through distributors, a "sell your pictures kit," as well as marketing consultation and review. The fact that PSI President Albert Moldvay was staff photographer and picture editor at *National Geographic* for many years adds considerable credibility and value to that service.

Dale Neville's "Superbull" Club, which you'll hear more about in the darkroom chapter, packs every newsletter with cost-cutting tips like beating Kodak's formulas, finding substitute developers, learning what you really wanted to know about Cibachrome (but were ashamed to admit you weren't too rich to ask), using cost-effective E-6 Ektachrome processing. They also have periodic sales of custom darkroom equipment and a low-cost consultant service for members.

Associated Photographers International offers these benefits, among others: a monthly newsletter that shows you how to generate income from your photos (and how to create better ones); cameras and lenses at low dealer net — "the lowest legitimate price available anywhere in the country"; up to 40 percent discounts on anything found in a well-stocked camera store (except film); a 25 percent discount on photo books, as well as additional discounts on magazine subscriptions and other services; wholesale business aids, such as business cards and matching stationery; access to a worldwide equipment protection program and an "all-risk" equipment insurance policy, and other full insurance coverages. You get all that for $25.

All in all, the economic advantages alone justify most memberships and repay the modest dues,

Though they don't broadcast it, they give club members 15 percent discounts on everything in the store.

*Most people
will continue
to pay for one
roll at a
time for
the rest
of their
lives, all
in the name
of economy.*

but I wouldn't expect anyone to sustain member-
ships at all the national clubs simultaneously. You
might try writing them all, however, and asking
what they can do for you, then pick and choose.
The following is a list of most of the major clubs and
associations. Some will accept anyone who pays
and some require certain qualifications. I'm certain
if you ask that they'll all brag about their benefits.

Associated Photographers International
21822 Sherman Way
Canoga Park, California 91303
213/888-9270

Educational Film Library Association
43 W. 61st Street
New York, New York
212/246-4533

Industrial Photographers of New Jersey
Two Columbine Road
House Station, New Jersey 08889
201/534-9637

Photographic Society of America
2005 Walnut Street
Philadelphia, Pennsylvania 19103
215/563-1663

Professional Photographers of America
1090 Executive Way
Des Plaines, Illinois 60018
312/299-8161

American Society of Magazine Photographers
205 Lexington Avenue
New York, New York 10016
212/889-9144

American Society of Picture Professionals
Box 5283
Grand Central Station

New York, New York 10163
212/682-6626

Friends of Photography
Sunset Center, Box 500
Carmel, California 93921
408/624-6330

National Press Photographers Association
Box 1146
Durham, North Carolina 27702
919/489-3700

Photographic Society International
1380 Morningside Way
Venice, California 90291

Price Freeze on Kodak

Another way to beat Kodak-the-giant is to pur-
chase their processing mailers at quantity discounts
or through wholesalers, which Ol' Man Yellow
vows to honor at any time in the future. Pay today's
prices tomorrow, or through the next decade if you
wish, in defiance of whatever inflation brings on the
rest of us. A good place to buy discount Kodak pro-
cessing mailers is the Camera Corner, Box 1298,
Burlington, North Carolina 27215, or call 919/228-
0251.

One way to use these mailers is not to mail
them. Simply toss your film in the bag and drop it
off at your local dealer for standard overnight ser-
vice. It will return on time with no charge. You
won't make friends at the photo shop since they're
used to taking a cut from Uncle K, but I didn't
promise more friends — just extra cash.

Not long ago my father mentioned an adver-
tisement he once received from *Reader's Digest*.

The offer was a lifetime subscription for $25. At the time the dollar or two annual subscription rate seemed the better deal. Make your own deductions, but within a few years from now *annual* subscription rates may be pushing $25. Film processing is no different, but most people will continue to pay for one roll at a time for the rest of their lives, all in the name of economy. Not us, right?

The discount was granted, which he's been exploiting eversince.

Free Enlargements

Many photo stores offer free enlargements with a certain number of receipts kept from processing. Nineteen stores around the Chicago area have an agreement to offer one free 5×7 print with $10 worth of receipts, a free 8×10 color enlargement with $20 worth, and a 16×20 with $50 worth of receipts. It's kind of like dividends on your stocks. If you're going to spend money on enlargements, you might as well spend it where you get a return. At least that's the way they hope we'll reason.

Push Kodachrome

You still might get that sick feeling when you discover film shot at the wrong ISO. But with Ektachromes there has always been an recourse — push processing. Ill-exposed Kodachrome on the other hand, almost always led to ulcers because there was no cure. Now there is. Dynacolor Labs at 11915 Olympic Boulevard, Los Angeles, California 90064, 213/478-0508, will push Kodachrome up to two and a half stops or pull it one stop. (If all this

pushing and pulling around sounds rough to you, don't worry; they don't really knock the film around. It means you can shoot Kodachrome 64 up to ISO 400 or down to 32 and they can somehow compensate for the error while processing.) The service runs $15 extra, but it sure can make you feel good in a hurry.

Internegs

Occasionally slides will print better from an inter-negative than directly. Inexpensive internegatives for $1.50 each are available from PSR, 2578 E. 21st Street, Brooklyn, New York 11235. Filter and expo-sure recommendations are furnished with each neg-ative.

When it's quality you're after you can waste money trying to save it. Unquestionably the finest internegatives made today are laser negatives that aren't quite free ($16.50 a hit), but they'll outshine anything you care to compare them with. For com-plete details write to Laser Color, Box 8000, Fair-field Drive, West Palm Beach, Florida 33407, 305/848-2000.

Some labs use computers; others use chimpanzee

Super Dupes

I'm all for getting the best deal right up to the point where it starts to intrude on quality. Then I tend to ease off if there's any hint of conflict. One place I don't like to skimp on is reproduction duplicate slides of those once-in-a-lifetime shots. If you spend money on a good dupe it not only makes the slide last indefinitely, but allows you to use it more

If you thought Fast Foto prices were low— and they are— consider these.

liberally. And if you market your pictures, dupes can save you enormous amounts of worry and money.

The best repro dupes I've come across are those produced by an aerial-image camera designed by Jeff Whatley of Comcorps, 711 4th Street N.W., Washington, D.C. Duplicate 35mm slides run $7.50 each, but if that can keep an original slide from potential damage or loss it might be worth a thousand times that.

It's also possible to have 4×5 dupes made from 35mm slides, and the best source for those is Creative Color, 4911 W. Grace Street, Tampa, Florida 33607, 813/879-5680. Reproduction duplicates from any size original on positive or negative film are converted to 4×5 for $18, 5×7 for $25 and 8×10 for

Sending contact sheets with original film is one of four good ways to help it survive picture editors.

$30. You may ask what prices like *that* are doing in a book like this? Simple: Saving an original image that cannot be rephotographed is a priceless service at any cost.

Custom Color

If you have C-41 color film that needs push-processing, or custom development needs, or just about any kind of film flub-up that needs fixing, Dale Neville can work the magic. Write to him at 153 Thurston, Kenmore, New York 14217, or call him at 716/876-7433 for a price quote.

Special Formulas

Anytime you have unconventional film-developing situations, Photographers' Formulary will prescale formulas on chemicals for any developing needs. Chemicals will be shipped in any quantity with a free catalog from Box 5105, Missoula, Montana 59806, or call toll-free 800/543-4534.

You won't make friends at the photo shop, but I didn't promise friends— just extra cash.

Cheap Cibas

One of the least expensive labs offering Cibachrome prints is G-B Color Lab, 18 Missionelle Court, Hawthorne, New Jersey 07506, 201/472-8885. Four-by-five enlargements run $3.95; 8×10 — $6.95; 16×20 — $21.95. All prints are made with Cibachrome professional materials and human-op-

erated enlargers (in contrast to some labs that use computers and others that use chimpanzees).

Contact-Printed Slides

A large photo lab in Chicago offers a 10 percent discount to anyone who walks in the door with a business card.

One alternative to sending out original color slides in large numbers is to send color contact sheets. A single 8×10 sheet displays 35 slide images. Solarcolor at Box 69279, Los Angeles, California 90069, will print your slides for $7.50 a page for the first sheet and $5 for each additional one. Or you can print your own with Ilford's slide printer easel.

Another alternative is to have your slides processed by Kodak and request contact strips. For an extra $1.50 they will contact print the entire roll of slide film before it's cut and mounted and returned as usual. Well worth the price if you need both prints and film.

Spend 20 Cents and Save 20 Bucks

Craftsman Color Labs, 132 Front Street, Hempstead, New York 11550, will trade a 20-cent stamp for a $20 credit certificate. That's how badly they want you to try their lab, or how confident they are that you'll keep using them from then on. Naturally the whole idea would flop without a limit of one per customer and — more importantly — if their introductory prints weren't dazzling. Anyway, to begin with you can't lose. Trade 'em! And then, doesn't your sister live across town? And she has in-laws . . .

Know of Any Used Scuba Gear?

What it all comes down to in the end is that there is no quick inoculation against photo inflation, or anything else I know of. Big savings come from little savings — made consistently. One tip used one time won't make much difference, but some of the tactics used most of the time will make all the difference. And if everyone used *all* these measures *all* the time — well, we know what that would be worth.

Now if we could just figure out how to retrieve all those Leicas from the San Francisco Bay. . .

4

Equipment Economy

No question about it, photographic technology is on a rampage. Today's cameras turn themselves on and off, focus themselves, load and wind themselves, and decide the best shutter/aperture combination. One or two even bitch at us when we try to do it our way. Which is all fine by me as long as I don't have to pay for such extravagance, and I don't. But then neither do you. Now it may take the rest of this chapter to explain my way out of that one, but it won't be hard.

Not too long ago I picked up a 1957 issue of *Popular Photography* magazine. The first thing that seduced my attention, besides the hair and bikini styles of that era, was a full page ad for the Beseler 23C enlarger listed for $187. It looked identical to the 23C-II in my darkroom which retailed for $190. Over that period, spanning nearly my entire lifetime, there's been a $3 price increase. So what's all this whimpering about the cost of photo equipment?

And the Beseler was by no means an isolated

exception either. Most of the cameras advertised in that issue were going for about $250 back when we were all still babes in the cradle. Today the average price of a camera body remains around $250, and for the same price look what we get. Instead of wooden boxes that barely hold the film in place we have nuclear-age cameras that have higher IQs than we do. Imagine what it would have been like to convince one of those mid-century shutterbugs that if he'd quit swearing at his belligerent light box long enough he'd be able to buy a camera that would talk back to him. For the same price.

To be sure, cameras and lenses are one of the best inflation deflators in sight, even at list price. I'll admit not all of them have equal value. But let's agree on one point: Today's price of hardware is equitable indeed. With that aside — along with the complainers, I hope — here are some ways to make prices fairer still.

Yes, I was tempted to digress into that vicious tangent about the dubious quality of the cameras we get today for yesterday's price but quickly abandoned the thought. Don't read me wrong; I agree, but I also fear it would only lead to war over a topic this book did not promise to address. Back to buying.

We have nuclear-age cameras that have higher IQs than we do.

Going Local Is Not Going Loco

Now this may cause an outburst in itself, which is fine by me. Tight photographers, as if there were any other kind, consider it foolish to buy camera equipment from the local camera shop. But I don't and here's why: If you check prices closely, your local store may not be that far adrift. As I write this we have more than 300 camera models to choose

from and as competition intensifies the margin of profit decreases, narrowing the possible fluctuations among distributors. Many larger stores that buy to their advantage in great quantity sell a few of the highly visible models at cost in order to advertise those prices and to con the public into believing everything else is priced accordingly. I've seen "unpopular" items sell for less at my neighborhood retailer than at the major dealers. So compare before you buy.

Another advantage to buying local, besides convenience and speed, is that you see what you get. Mail-order purchasing may save you a dollar or two up front, but if it's not quite right or if you just decide you don't want it, try returning it without losing your shirt and sanity. (If it comes to that, see advice below on saving both.)

Local stores need repeat business and they bend over backward to prove it. One patron of a store in my neighborhood explained how he purchased an off-brand camera system there and when he got home found a crack in the lens element. The clerk apologized and gave him a new lens. That one turned out to have a hairline crack as well and was exchanged yet again. He said their cooperation gave him confidence in the store. Me too, but I wanted to ask if the incident didn't also shake his confidence in the inexpensive brand. But that's another story.

Finally, your nearby photo shop will probably give more (and better) advice than its snobbish big brothers. Not to wear out Du Page Photo, though they are handy, allow me just one more reference. A short time ago I asked Tim, the assistant manager, to sell me a Kodak Ektaflex system with paper, chemistry — the whole shot — but he wouldn't. I was ready to buy, my wallet was bulging, yet he refused. "I won't take your money," he argued. "We should be getting the new Agfach-

So what's all this whimpering about the cost of photo equipment ?

rome Speed paper in a few weeks, which comes in various sizes and needs no gadgetry to process. It's easier to use and will save you $150." He lost my one-fifty and gained my loyalty — a sensible trade.

I'd suggest giving the locals a chance first for the advantages they offer, but don't buy blindly. If you can save one or two hundred bills on one item by going elsewhere, then by all means go. And if that means through the mail then don't miss the next section.

Deadly Mistakes for Direct Mail

Try returning it without losing your shirt and your sanity.

Don't ever order equipment by mail. Our industry changes too fast, and by the time your order arrives there could be two new models. Besides, it invites unscrupulous dealers to play with your money. Instead, order over the phone or over the counter.

Never accept a substitute item if yours is not available. It's a common maneuver to replace what you want with a less expensive variety. Even if it's not a ploy you still should compare prices for that new model before accepting. One guarantee — you can be sure they won't be swapping anything of *greater* value.

If you must return an item send it insured with a return receipt so you can prove it was received should a shouting match ensue.

Keep a record of the time you placed your call, the details of your conversation, and the name or number of the person who took your order. Recording the conversation is one safety precaution. Verify explicitly what you want with all its components and accessories.

Don't let them tell you they expect a new shipment in a week. Tell them you'll call back in a week.

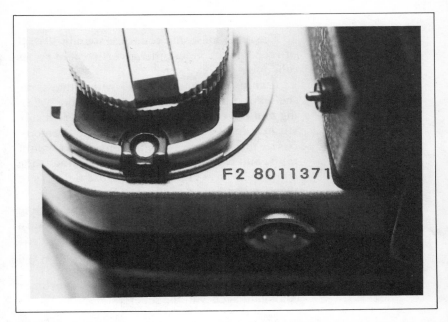

Buying used camera equipment isn't as risky if you know 15 crucial points to check, like the date of manufacture stamped into the first two digits of the serial number on this 1980 Nikon F2.

Demand the total cost, including "handling," "shipping," "insurance," "Blue Label," or other items that mysteriously appear on the invoice, and state that no additional charges will be paid after the clerk's confirmation.

You might want to ask some of the following questions: Is the warranty national or international? Who should you contact in case of error? Is the equipment available for immediate shipping? Are all the necessary parts from the same manufacturer?

The following is a list of your rights whenever you buy anything through the mail according to the Federal Trade Commission:

If he'd quit swearing at his belligerent light box before long he'd be able to buy a camera that would talk back to him — for the same price.

1. The seller must ship your order within 30 days of receiving it, unless the advertisement states otherwise.

2. If an order cannot be filled within that time, the seller must notify the buyer in writing, offering him the opportunity to cancel, accept a substitute (don't), or agree to the postponement. Notice must include a stamped envelope for your reply, and if you don't choose to respond, then another 30 days are allowed before delivery of the merchandise or a full refund.

3. You have a right to cancel the item anytime before it has been shipped, and you can return any item within ten days after receiving it.

4. Cancellations must be refunded within seven working days. Store credits will not suffice.

5. If any problem arises contact the consumer complaint agency in the seller's state.

Typical Traps

Watch out for the strippers wherever you go. Some disreputable dealers disrobe the camera of all its rightful accessories, such as straps, body caps, batteries, lens caps, and leather cases. In fact, some retailers have even replaced systems lenses with less expensive off-brand lenses.

Some disreputable dealers disrobe the camera of all its rightful accessories.

Beware of cameras that don't arrive through customary channels. For instance, Minolta says that when buying their camera through "gray" retailers, you'll receive only an international warranty rather than a U.S. warranty, in which case you may have to send the camera overseas to have it repaired. Some dealers have been known to advertise at a low price, and when they receive your check they'll write back a month later telling you the item

is out of stock. Then they'll ask if you'd like to wait two months or purchase a different model. It's often a scam to use your money, so demand a refund.

Bert Eifer of Associated Photographers International says, "Another trick is to send you an older model and sometimes you'll never know. It's easy to tell a Canon A-1 from an AE-1, but can you tell a new lens model from an old one? Sometimes you will receive the wrong items, and before things are straightened out 90 days may have gone by. You see, the name of the game with unscrupulous dealers is to keep your money as long as possible. There are some mighty good ways to make money in 30, 60, or 90 days. The invested money is worth more than the sale. We encourage you to find good buys, not goodbyes."

The way to avoid being taken on mail-order purchases is to call in your order. Verify the items discussed above, charge it to a credit card, and request the equipment be mailed that day. When it's an option, order by COD.

All this could easily spook anyone from buying anything by mail. Well quit shaking — those were just the preliminary formalities. Actually there's nothing to it; I've bought thousands of dollars worth of photo equipment through the mail and have never been bit. I just wanted you to brush up on your self-defense before I sent you to the dogs. Undoubtedly, sooner or later mail-order houses will have the best price. For instance . . .

The Best Buys

One of the largest stores offering equipment at reduced prices is Olden, 1265 Broadway at 32nd Street, New York, New York 10001. You can order

equipment over the phone by dialing 212/C-A-M-E-R-A-S.

Another outlet that not only sells but will also give you a trade-in or buy used equipment outright is Bennett Camera Exchange, 2611 Lee Road, Winter Park, Florida 32789, 305/644-9684.

This camera broker in Georgia will buy, sell, or trade used equipment and offers a 60-day warranty with all used cameras plus a 20-day return privilege if dissatisfied. Their primary interest is in Hasselblad, Leica, Rollei, Contarex, Linhoff, Sinar, and Deardorff. People who wish to sell equipment get to use the WATS line, 800/241-5694. Everyone else must dial 404/892-5522 or write to KEH Camera Brokers, 1050 Spring Street, N. W., Atlanta, Georgia 30309.

He lost my one-fifty and gained my loyalty—a sensible trade.

Nikon owners will find the lowest prices on nearly any new piece of equipment (and many used ones) from Peter Gould, who will buy, sell, or trade, too. Free delivery. Write Box 838, Newark, New Jersey 07101, or call 212/675-3707.

Unity Buying Service, Box 3004, Hicksville, New York 11802, is not strictly a photo dealer but offers prices that compete with some of the largest discounters. Unity is a "membership" buying service with $6 annual dues, which means if you don't buy you won't save and of course the reverse is also true. Joe swears by them.

Here's a good one for the folks who can talk a fast deal. Jack's Loan at 1608 Broadway, Gary, Indiana 46407, 219/885-4030, claims to be mid-America's largest pawnshop, but doesn't evidence any knowledge about camera pricing. Witness a whole assortment of Polaroid cameras (including an SX-70) going for $25 a pair, a Nikkor 5×7 enlarging system for $100, Minolta SR-1 with a Rokkor 1.8 lens for $49, and the like. Quick, buy what you can before Jack wises up, and in the meantime don't anybody pass on my summation of his operation. If you

tell him anything tell him I said he was doing a great job — maybe a little high . . .

Photo Imports deals with out-of-business equipment sales. They purchase large quantities of equipment being liquidated from all over the world and sell it for base prices. Cameras, lenses, electronic flash units, movie cameras and accessories at below cost. Filters can be had from two cents each; sunshades from 25 cents each, and more. Write for their free *Closeout Bulletin* at Photo Imports, Camera Warehouse No. 5, Box 87, Bronxville, New York 10708.

Camera Traders Limited of New York are — well, I guess it's obvious. Anyway, they have a pretty good selection and not bad prices. They'll buy, sell, or trade any way you want. Find them at 1837 Ocean Parkway, Brooklyn, New York 11223, or call 212/336-6667.

Free Advice

Just as a general principle, regardless of what you purchase or from whom, beware of substitute plastic parts used in places like the lens breech (Canon AE-1 and others) or the take-up spool. They'll wear out faster than your patience, which of course is the intention. Another defect I'd avoid like the black plague is a black body, which is currently in vogue, but will show more wear and bring less money when you get ready to sell or trade.

Your nearby photo shop will probably give more (and better) advice than its snobbish big brothers.

Pros and Cons of Used Cameras

So much for new equipment purchases. But no word on used equipment? Well, before you inter-

rupted I was just about to say "I'm all for it and all against it." Sometimes older is better. Back in the mechanical days when cameras, watches, cars, and the like ran on the tooth and sprocket system, it was clearer when the tool was or wasn't up to par. Nowadays electronic components have a way of hiding their faults, like an electrical short that drains the batteries slowly. Buying used electronic cameras can be risky, but not many of the other kind are made anymore. Still, if you like the older Canon F-1, the Nikon Ftn or F2, or the other "tanks" of yesterday, have at it.

Never buy a used camera from me or anyone who works equipment as I do.

Jim Tallon, a hard-shooting wildlife photographer, has bought dozens of Canon F1s over the last two decades and summarizes the present market like this: "The major manufacturers ride a madcap bandwagon to produce similar versions of everyone's similar versions. New model after new model floods the market in what accurately fits the hip term 'planned obsolescence.' If any good has come of this it is the untold tons of used equipment being dumped onto the market at low prices. But never buy a used camera from me or anyone who works equipment as I do. Better to buy from an amateur, especially if he likes cameras more than he does photography." If you know what to look for, it's obvious how the camera has been used or abused. If you don't know what to look for, read the next paragraph.

Tattletale Cameras

Often telltale signs showing the camera's wear and age catch the attention of experienced eyes. Some cameras, such as Nikons, incorporate the year of manufacture into the first two digits of the serial

number on the top of the body. Determine the camera birthday by reading it. A good check to see the extent of camera use is to look at the neckstrap eyelets. Well-used cameras will have well-worn eyelets, sometimes to the danger point. Still another way to check for wear is to open the back of the camera and look for a vertical looseness in the takeup spool.

Lenses, on the other hand, are a cinch to evaluate. Most damage on the outside (nicks and dings, worn edges, scratched lens elements) is obvious. Loose internal elements will rattle when you shake the lens. There are lots of used lenses out there that are as safe and sound as used real estate. People have the flimsiest excuses for abandoning solid lenses — rarely due to misbehavior on the part of the lens. "I never use it anymore; I bought a faster one; it makes everything look too tiny; it doesn't work with my flash; I got a zoom instead" — are all the kinds of excuses that make great reasons for buying.

Play it safe, though, before you buy. Any reputable camera seller will allow the buyer to run a test roll of film through the camera — the best lie detector there is. If he won't, hand the camera back and don't bother to thank him. Use slide film — it's more candid than negative film, and shoot an optical test chart or some other flat object that will reveal edge to edge sharpness.

A preliminary test to see if the lens is sharp is to "back-sight" it. Set the focus on infinity, place the back of the lens on a sheet of printed paper, and hold it up to a light source. When looking through the front of the lens the type should be tack sharp. That can tell you if there is major misalignment, but the only sure way to test a lens without elaborate equipment is to shoot a test roll for the price of the film. Check for bayonet wear on the rear of the lens and smoothness in the focusing movement.

A Beginner's Guide to Evaluating a Used Camera

If you still feel uneasy about taking home something that someone else has already played with, no need to. Buy the book with the above title written by Bob Lawrence, a noted camera repairman in Tennessee. A glance through this volume will give you X-ray vision next time you need to inspect a shopworn body. Send $5 to 205½ E. Sullivan Street, Kingsport, Tennessee 37660.

Blue Book Price

The body book can tell you what condition the camera is in, but it won't give a clue about the sales conditions. For that, get a copy of the current blue book, which updates the going prices for just about every piece of camera equipment made. It can be purchased for $12.95 from Myron Wolf Photographic Memorabilia, Box 351, Lexington, Massachusetts 02173.

Dumping Used Equipment

Then there's always the guy who has something that's not really worth anything and is looking for a sucker to dump it on. The Camera Clinic wants all the lousy stuff. One of their more memorable ads read: "Wanted dead or alive. Broken, smashed, water-damaged Nikon, Canon, Minolta, Pentax, and Olympus SLRs. Top prices paid." Please send

them your shady deals and they'll give you a price quote before purchasing. For more information write Camera Clinic, Route 1, Boone Lake, West Shore Drive, Exeter, Rhode Island 02822.

One easily overlooked telltale sign on used cameras is the neckstrap eyelets. They say a lot about how much use a camera has had.

The World's Lowest Used Prices

On the contrary, if it's used equipment you want to buy — not sell — and you've been looking everywhere, stop the search. You need go no further. *Shutterbug Ads*, mentioned earlier, lists 132,000 pieces of used photo equipment every month.

Better to buy from an amateur, especially if he likes cameras more than he does photography.

That's no sales gimmick figure either. I just counted them up in the latest issue — well, I counted them on one page and extrapolated. Give or take a few thousand, what does it matter; you'll still find anything you want and likely at a lower price than elsewhere. Check here first for a good comparison and you'll find yourself coming back time and again. The following is a list of product, supply, and service categories:

1. 2¼ SLR equipment for sale
2. 2¼ SLR equipment wanted
3. 2¼ TLR equipment for sale
4. 2¼ TLR equipment wanted
5. 35mm SLR equipment for sale
6. 35mm SLR equipment wanted
7. 35mm rangefinders for sale
8. 35mm rangefinders wanted
9. 35mm lenses for sale
10. 35mm lenses wanted
11. Leica equipment for sale
12. Leica equipment wanted
13. Press and view equipment for sale
14. Press and view equipment wanted
15. Stereo equipment for sale
16. Stereo equipment wanted
17. Antiques and classics for sale
18. Antiques and classics wanted
19. Images for sale
20. Images wanted
21. Darkroom equipment for sale
22. Darkroom equipment wanted
23. Polaroid for sale
24. Polaroid wanted
25. Subminiatures for sale
26. Subminiatures wanted
27. Movie equipment for sale
28. Movie equipment wanted
29. Camera parts for sale

30. Camera parts wanted
31. Slide equipment for sale
32. Slide equipment wanted
33. Movie reels for sale
34. Movie reels wanted
35. Exposure meters for sale
36. Exposure meters wanted
37. Studio equipment for sale
38. Studio equipment wanted
39. Strobe equipment for sale
40. Strobe equipment wanted
41. Film for sale
42. Film wanted
43. Aerial equipment for sale
44. Aerial equipment wanted
45. Roll-film cameras for sale
46. Roll-film cameras wanted
47. Books and magazines for sale
48. Books and magazines wanted
49. Swap and trade
50. Mail bid
51. Stolen equipment
52. Underwater equipment for sale
53. Underwater equipment wanted
54. Folding cameras for sale
55. Folding cameras wanted
56. Graphic arts photo equipment
57. Help wanted
58. Situations wanted
59. Miscellaneous equipment for sale
60. Miscellaneous equipment wanted
61. Nonphotographic equipment
62. Photographic businesses for sale-wanted
63. Supplies
64. Repair and test equipment
65. Video equipment for sale
66. Video equipment wanted
67. Binoculars for sale
68. Binoculars wanted

69. Miscellaneous services
70. Telescopes for sale
71. Telescopes wanted

And if you can't find it there, you stopped at the wrong planet. *Shutterbug Ads*, Box F-840, Titusville, Florida 32780.

So if you don't buy you won't save, but of course the reverse is also true.

Rent, Don't Buy

One way many photographers waste much money is by purchasing equipment, new or used, they rarely use, which is one of the main reasons it goes back on the market — usually at a loss. Why not rent a piece of equipment first before purchasing it? The following is a list of typical rental items from one of the stores listed at the end of the chapter. These are one-day prices, and all items are rented by the week for three times the daily rates.

Nikon bodies
 Nikon F, Ftn or F2, body only, $7.50
 Nikon F, Ftn or F2 w/50mm f/1.4, $10
 F-36 motor drive, body only, $20
 F-250 motor drive, body only, $30
 Motor drive for F2, $12.50
 250-exposure back for F2 (requires motor drive), $10
 Nikon FE body, $10
 Nikon FM2 body, $10
 Nikon F2 body, $12.50
 Nikon F3 body, $15

Nikon lenses
 6mm f/2.8 Nikkor fisheye, $90
 6mm f/5.6 Nikkor fisheye, $25
 7.5mm f/5.6 Nikkor fisheye, finder, case, $15

8mm f/2.8 Auto Nikkor fisheye, case, $18
10mm f/5.6 Nikkor OP fisheye, finder case $18
13mm f/5.6 Nikkor Auto wide angle, $75
15mm f/5.6 Auto Nikkor, $25
16mm f/3.5 Auto Nikkor fisheye, $12.50
18mm f/4 Auto Nikkor, $10
20mm f/3.5 auto Nikkor, $7.50
20mm f/4 Auto Nikkor, $7.50
24mm f/2.8 Auto Nikkor, $7.50
28mm f/2 Auto Nikkor, $10
35mm f/2.8 PC Nikkor, $7.50
45mm f/2.8 GN Auto Nikkor, guide number, $7.50
50mm f/1.2 Auto Nikkor, $15
50mm f/1.4 Auto Nikkor, $5
58mm f/1.2 Auto Noct Nikkor, $25
85mm f/1.4 Auto Nikkor, $15
105mm f/1.8 Auto Nikkor, $15
180mm F2.8 ED Auto Nikkor, $20
200mm F2 ED IF Auto Nikkor, $50
300mm f/2.8 ED IF Auto Nikkor, $50
300mm f/4.5 ED IF Auto Nikkor, $25
400mm f/3.5 ED IF Auto Nikkor, $50
500mm f/5 Reflex Nikkor, $30
500mm f/8 Reflex Nikkor, $25
600mm f/4 ED IF Auto Nikkor, $60
800mm f/8 ED IF Auto Nikkor, $50
1000mm f/6.3 Reflex Nikkor, $60
1000mm f/11 Reflex Nikkor, $37.50
1600mm f/16 Questar, $50
25–50mm f/4 Auto Nikkor Zoom, $20
28–45mm f/4.5 Auto Nikkor Zoom, $17.50
35–70mm f/3.5 Auto Nikkor Zoom, $17.50
43–86mm f/3.5 Auto Nikkor Zoom, $10
50–300mm f/4.5 Auto Nikkor Zoom, $40
80–200mm f/2.8 ED Auto Nikkor Zoom, $40
80–200mm f/4 Auto Nikkor Zoom, $25
85–250mm f/4 Auto Nikkor Zoom, $25
200–600mm f/9.5 Auto Nikkor Zoom, $35

Nikon Camera Accessories
 MD2 motor drive for Nikon F2, $20
 MF1 250-exposure back for MD2, $25
 MD3 motor drive for Nikon F2, $10
 MD4 motor drive for Nikon F3, $15
 250-exposure film loader cassettes, $5
 Forscher F2 Pro back for Polaroid 100 film, $10
 Forscher F3 Pro back for Polaroid 100 film, $10
 4×5 Speed Magny back for F2, $15
 Intervalometer, $15

Other bodies, lenses, accessories, and camera brands are also available for rent, but typing this small portion bored the fool out of me and I'm confident it did as much for you. So I'll quit, but this will give you an idea of what's available and typical prices for 35mm SLR stuff. Also at this particular shop are these additional general categories of rental equipment:

Binoculars and Spotting Scopes
Electronic Flash
 Speedotron
 Ascor
Film Editing
Lighting
 Quartz Halogen
 Stands
 Mounting accessories
 Grip equipment
 Electrical distribution

Motion Picture Equipment
 Cameras — Arriflex, Eclair, Cinema Products, Bolex, Canon
 Editing
 Optics
 Support
 Sound

Presentation
Motion picture projectors
Still projectors
Programmers and dissolves
Public address
Miscellaneous

Still Camera Equipment
Wide Angle

View Cameras — Sinar, Deardorff, Crown Graphic, Omega, Toyo
Tripods
Exposure meters
Filters and lens accessories
Medium format — Hasselblad, Mamiya
35mm format — Nikon, Canon
Miscellaneous

Underwater Photographic Equipment Video
Equipment — Sony

Okay, okay enough of this. Anyway, that's what there is and here's where to get it:

Brooks Camera
45 Kearny Street
San Francisco, California 94108
415/392-1900

Claus Gelote
185 Alewife Brook Parkway
Cambridge, Massachusetts
617/868-2366

Olden Rentals (they'll ship anywhere in the world)
1265 Broadway
New York, New York 10001
212/725-1234

Standard Photo
43 E. Chicago Avenue
Chicago, Illinois 60611
312/440-4920

Helix Rental
325 W. Huron Street
Chicago, Illinois 60610
312/944-4400

In short, neither photo technology nor the cost of it is likely to diminish anytime soon. But then if it follows the trend of the last 30 years we won't need to worry about prices going up either. The best approach I see is to take advantage of the advances without paying for them — and waste not.

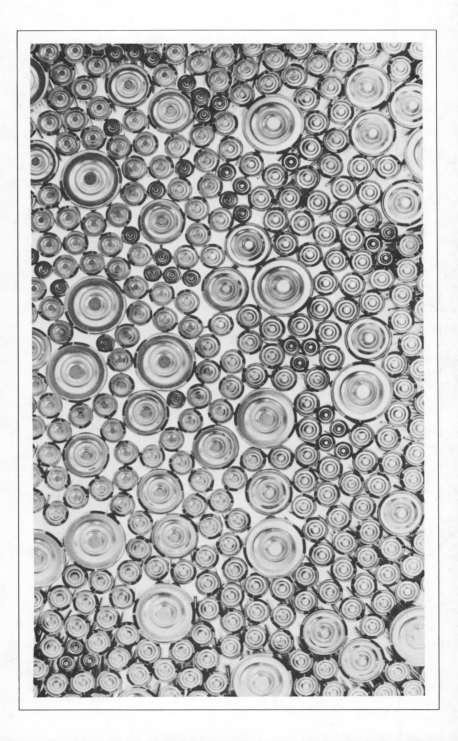

5

Battery Savers

Wait! I already know what you're thinking — that you can't believe I'd have the mettle to spend a whole chapter on batteries. I haven't even spent a sentence yet, but you're right — I aim to. Not because I think there's a lot to say about batteries, but grouping the ideas together here will provide easier access. Besides, batteries *are* important.

Don't tell me you can get along without them. Electronic flash units where magnesium powder once sufficed, motor drives in place of cranks, light meters rather than charts, and other previously nonexistent photo aids, like remote control or burglar alarms, have all been given to cell-dependence.

In fact, batteries are the life-support system of today's cameras. I can count on one hand the cameras that don't need electrical power to operate both shutter and built-in meter. Bless them. And according to a well-known Chicago camera repairman, the single most common failure of modern cameras is, as a result, battery-related. It would be reasonable then to assume that halting battery

Halting battery problems can save considerable camera downtime, to say nothing of financial and emotional downers.

problems can save considerable camera downtime, to say nothing of financial and emotional downers.

Here is the best way to squeeze more juice and dollars from your dry cells.

Extending Battery Life

Of the various techniques used to prolong the life of a battery, by far the most sensible is to start with a fresh one. Make sure you're buying "new" batteries from the store by opening and testing them right there. When the belligerant clerk swears they just came from the factory yesterday (they all say that), just smile and tell him to hand over his battery tester. Most places selling batteries also have battery testers, and if they don't you may have reason enough to buy elsewhere. As you leave ask the fellow if he goes to a barbershop without mirrors.

Change them once a year whether they need to be or not. Don't argue, just do it.

Whatever, don't let the battery tester fail you. Joe has this caution: "Most battery testers are useless in telling how 'fresh' a battery is because they measure voltage of the battery in an 'unloaded' condition. The only accurate way to determine the condition of a battery is with an 'extended-scale' meter which simultaneously applies a drain to the battery approximately equal to its current drain in the application in which it's to be used." In other words, don't trust the kind that has a light bulb connected to two wires.

Often the batteries may still be good, but poor contact, corrosion, or other inhibitors prevent full electrical current. Whether the batteries actually leak or not, most will produce corrosion on the terminals given time. Such corrosion will lead to more rapid drainage of cell power, and should therefore be cleaned from the terminals and battery posts pe-

riodically. This is best done with a pencil eraser (not an ink eraser) to remove any white flaking (oxidation) or green corrosion. Frequently cleaning the batteries and terminals alone can rejuvenate a dead camera.

The next best trick if you can't scare up an eraser is to strike the battery across a low-pile carpet as if you were trying to light a fat match. Just tell the curious onlookers that you're using "wind-up" batteries.

Regardless, no batteries should be trusted longer than a year. Change them once a year whether they need to be or not. Don't argue, just do it. And if you can't remember when you last

It may be a hassle, but one bad experience will make you wish for a second chance to be bothered.

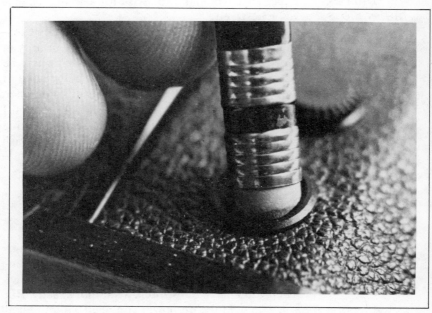

A pencil eraser can correct many a camera malfunction, but don't stick it in the wrong hole.

changed them, it's a good clue either your battery cells or brain cells need replacing.

The next step in battery health care is keeping them alive. Batteries should not be stored inside equipment for long periods of time. "Long" in this case means more than a few weeks, since weak batteries may deteriorate other nearby cells, like the proverbial rotten apple. Then too, every battery is a potential cancer cell. If it leaks electrolyte inside the battery compartment the repair bill can rupture a healthy wad of currency. So if you expect an idle period of time for your equipment, such as the winter season for some photographers, or if it just sits on the shelf for a month, remove the batteries from the compartment. It may be a hassle, but one bad experience will make you wish for a second chance to be pestered.

Unfortunately, like people, all batteries eventually die. If your camera is electronic — or uses an electronic shutter and cannot be operated when the batteries go dead — you'd better get in the habit of carrying spares. At all times. You never know when your camera may have a coronary attack. In fact, I try to keep spare batteries around for everything that uses them: light meters, motor drives, flash units, battery packs, electric socks, whatever.

I can count on one hand the cameras that don't need electrical power to operate both shutter and built-in meter. Bless them.

Reusable Batteries

Always use alkaline batteries. Most camera equipment pulls a pretty heavy drain, and using carbon-zinc batteries is like trying to get by on matches when you need a blow torch. Well, not exactly. But you won't get the firepower you need without alkalines.

Rechargeable batteries are a better investment still, because they can be brought back from the

dead many times over. They may produce less voltage than their one-life counterparts, but they're more durable in winter. Also, the nickel-cadmiums ("nicads" in slang) will usually last longer between charges. They cost three or four times that of the standard batteries, but then they can be revived several hundred times. I'll let you figure the equivalent value.

Then too, you can carry several battery packs with you and rotate them as needed. Such a system is particularly effective in winter when periodic pocket warming can keep them functioning. But make sure your equipment was designed for use with nicads or you can permanently damage electronic components, especially flash units and motor drives.

Tips for Battery Abusers

Don't ever touch the battery contacts with your fingers — they leave oil on the surface. There is nothing wrong with the oil, but it contains a percentage of acid (different amounts for different people) that will corrode the batteries prematurely. Wipe the contact points off with a dry cloth before insertion.

Heat ruins batteries just as it does film, so store your spare ones in a cool, dry place. According to the National Bureau of Standards, freezing batteries will slow their deterioration to a trickle. Since batteries wear down faster in winter the fridge might seem like a foolish place to store them, but in an unloaded condition the chemical reaction is slowed considerably and the battery is spared. So the reverse is true in heat.

In the end when your penlight batteries do wear out don't chuck them. Many other appliances

They'll wear out faster than your patience, which of course is the intention.

attery MN2400B2
batteries

9G27 2

Copper Top Battery ™ lasts longer *

_L® batteries can last up to 5 times longer*

LL® batteries can last up to 4 times longer*

JURACELL® batteries can last up to 4 times longer*

batteries can last up to 3 times longer*

tteries can last up to 6 times longer*

Unscrambling codes on battery packages can save you the maddening expense of buying old/new batteries. This one was produced on July 27, 1979.

Rechargeable batteries are a better investment still, because they can be brought back from the grave several hundred times.

don't draw as much current, so you can keep using them in calculators, clocks, timers, and other household appliances.

Believe it or not, weak batteries wreck a lot of film. The problem is that light meters may continue to operate before the batteries go completely dead — lying about settings. You might not realize it until it's too late. Solution:

First, make sure you replace your batteries once a year, whether they need to be or not. I know, I already said that. But have you changed them yet? Okay then. And if you can't remember what batteries it takes write the number on the underside of the battery cap with a magic marker.

Next clean the batteries periodically and always carry spares. I know you know that too, but

I'm trying to generate a mental checklist here. This is the last; memorize it. On a bright, sunny day, with your lens at f/16, your shutter speed should be equal to the speed of the film you are using. In other words, when using Tri-X film with an ISO of 400 on a sunny day, your lens should be set at f/16 and your shutter speed should be reading 1/500 of a second (the closest figure to ISO 400). Using Ektachrome 64 it should read f/16 at 1/60th, and so forth. With such a back-up gauge you can always tell if your batteries are squirrelly.

When all else fails and even installing new batteries doesn't bring the light meter to life, it could be that an atmospheric deposit has built up on the needle interfering with its movement. You might be able to clear the micro-obstruction by moving the needle back and forth rapidly by changing the aperture and shutter speeds or aiming the camera at a bright light source and then covering the lens a dozen times or so. Such vigorous movements may dislodge the corrosion.

A Five-Year Battery

Duracell makes a three-volt lithium battery called the Duracell DL 1/3N, which will last up to five years in the camera. Price of the lithium battery is $3.90, and more information is available from Duracell International, Berkshire Industrial Park, Bethel, Connecticut 06801.

Silverless Batteries Save

If you're tired of paying outrageous prices for pin-sized silver-oxide batteries, switch. Eveready's

manganese dioxide substitutes cost a fraction of the
price and last longer to boot. An example is the
MS-76 battery, which normally sells for $3.95; its
manganese-dioxide clone goes for just 99 cents.
May silver-oxides forever rest in peace.

Good Batteries for Great Prices

*May your
batteries
always
be charged.*

You'll not find too many discounts on batteries, and
regardless, what's a percentage difference of half a
buck? Nevertheless, here's a place to get Eveready
Energizer double As for 60 cents or less if bought in
quantity. C and D sizes go for 80 cents each and
510-volt berthas go for $19.80. Camera World, 1809
Commonwealth Avenue, Charlotte, North Caroli-
na 28299, 704/375-8453.

Want to buy nickel cadmium batteries for near-
ly the price of alkalines? H & R Corporation sells
AA 1.2-volt nickel cadmium batteries at $2.50 each
or a pack of four at $4.50. Type C cells go for $3 and
a four-pack of D cells goes for $14.95. Of course
chargers for $10.75 won't be found for less. But you
can find H & R Corporation at 401 E. Erie Avenue,
Philadelphia, Pennsylvania 19134, 215/426-1708.

I'll close with the best wishes one fellow pho-
tographer offered to another who obviously pos-
sessed some faulty wiring: "May your batteries al-
ways be charged."

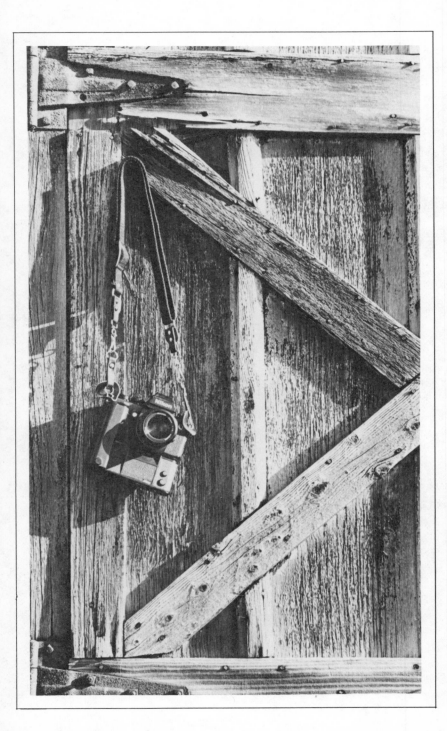

6

Extending Your Warranty

The age-old adage, "The best cure is prevention," holds as well for camera bodies as it does for human bodies. But you can bet neither doctor nor camera manufacturer broadcasts the advice these days. It would be like an auto mechanic selling self-maintenance manuals. Likewise I doubt this chapter will win me accolades from the Photographic Manufacturer's Association of America, but that won't quiet me.

With that established, here are some ways to make your camera last forever . . . or at least a lifetime.

The first way to reduce those heavy repair bills is to quit having repairs made. Of course, that's not entirely possible, but 90 percent of them can be prevented if proper steps are taken ahead of time. These tricks work:

Preventive measures are not much more than afterthoughts for some photographers.

Life Insurance for Lenses

Here are
some ways
to make
your
camera
last
forever . . .
or at
least a
lifetime.

Keeping a clear filter on the end of every lens will provide more protection for less money than Lloyd's of London would ever promise. Either a skylight filter (which warms skin tones slightly) or a UV filter (which cuts down haze), should be kept on the end of each lens you own. The camera's lens protrudes farthest and generally gets damaged first. Replacing a $10 filter will seem a relief compared to replacing a scratched front element for two or three hundred dollars.

Sell Your Body

People are beginning to swap cameras almost as frequently as they do spouses. In some cases, I've heard, an affair with the former leading to departure of the latter. But before you ditch your camera, I know a few things you can do to enhance its value before you let it go. I've given up offering advice on the other concern, though it hasn't always been like that.

A short time ago in the local photo shop, I ran into a coed from one of my photography classes who I guess assumed I would make the proper camera equipment inference when she asked me if I thought she should sell her body. "Oh no, don't do that," I cautioned. She insisted she had to because she needed the money, and I couldn't seem to sway her toward other alternatives. "Besides," she said, "this guy already offered me $200 without even trying it out." Well, I said I thought that sounded pretty daring, but that sight unseen I thought she was worth more than that. She paused only a moment before pelting me, and since then I've quit trying to

advise on body sales. Selling camera bodies —
now that's another matter. I do have a few opinions
on that variety. One way to get more for your body
is to keep it in top shape. Few advanced amateurs
and no pros I know can afford the time and hassle
of wrestling their cameras in and out of "never-
ready" cases. But when used with just a neckstrap,
the outside edges of the camera start to look scruffy.
That won't affect the quality of pictures the camera
makes but it will devalue the overall worth of the
camera when you get ready to sell or trade it. Halt
the brassing (an archaic term passed down from the
days when cameras were actually made of brass) by
lining exposed edges with strips of cut-to-fit duct
tape. A tape alternative is self-adhesive Mylar,
available at hobby shops, or you can paint chrome
edges with fingernail polish.

Often the base plate of the camera gets man-
gled the worst. Scratching around on a tripod head
trying to locate the socket or steadying the camera
on various outdoor surfaces generally leaves the
camera base looking like it's been cuddled by a road
grader rather than an artist. Needless wear can be
avoided by stretching several layers of duct tape
across the bottom, leaving holes for appropriate
connections. Active photographers are always in
need of tape to secure the aperture ring or sync
cords in place. Having a few layers on the bottom of
your camera protects the plate and also gives you a
quick source of tape when you need it.

Protect the backside of your camera by attach-
ing a collapsible rubber eyeshade on the viewfinder.
This not only provides viewfinder shading when
working with a strong sidelight, but also gives cush-
ioning to the rear of the camera when it is lying on
its back.

Another item that can help make your camera
last longer is a collapsible lens hood for use with
short lenses. These rubber shades screw in like a fil-

Everyone knows how tough it is to dislodge grit trapped in the lens barrel. The camera repairman gets it out by breaking down the lens and your bank account. You can accomplish the same thing with a business card and the right twist.

ter on the front of the lens. They collapse back flush with the lens or can be pulled forward for use as a lens shade. They catch front-end abuse instead of the lens whenever the camera gets manhandled.

Whether you want to hear this or not — there's a recourse for those tumble-polished cameras.

But If It's Too Late Already

With regret I realize all these preventive measures are not much more than afterthoughts for some photographers — the rough ones anyway. Believe me I can sympathize. My computer ate the first 40 pages of this book, let out a little belch, and they were gone just like that. And let me tell you there

were some gems in there too. I was heartsick. After starting over from scratch and working my way back to page 40, a friend dropped by and nonchalantly mentioned that some new firm is able to retrieve erased information by decoding magnetic residue left behind on the diskette. He said they charge something like $15.

Replacing a $10 filter will seem a relief compared to replacing a $200 lens element.

Anyway, getting back to butchered cameras — whether you want to hear this or not — there's a recourse for those tumble-polished cameras you're afraid won't sell. You can re-chrome worn parts with the Chrome-Tone Plating Kit from Judson Manufacturing Company, 321 Charles Street, Cherokee, Iowa 51012. One kit ($15.95) covers three to four square feet of metal surface, or roughly a large box full of threadbare cameras. And next time be more careful, huh?

Should it be the black surfaces that are fading here's a trick that works for aluminum alloys. Mix 42 grams of potassium permanganate with 10cc of nitric acid and 113 grams of copper nitrate in water to make 4,000cc. Heat the bath to 175 degrees Fahrenheit and immerse the part for 20 to 30 minutes. Rinse the baby off and you'll have a smooth black anodized finish. And if you're getting madder than Mr. T because you already dumped your cameras for almost nothing, hey, I know how it feels.

Camera Jams

No camera company has the monopoly on camera jamming, though quite a few concerns have been accused of such. Sometimes parts get jammed or become hard to move simply because the lubrication has evaporated. Dust that gets into the camera system will soak up the lubrication, causing it to

evaporate and leaving parts to grind against each other. The sensible way to avoid this is to store your camera in a dust-free habitat, such as a sealed case, rather than out on the dresser or stashed in the closet. Periodic lubrication by a qualified repairman also pays off. When you use your camera in a dusty environment be sure to clean it thoroughly because any dust on the outside of the camera usually — no, always — creeps inside.

Moisture Guard

The greatest threat to equipment in outdoor photography is moisture from humidity, rain, snow, and, worst by far, salt spray in coastal regions. Wimps solve the problem by leaving their cameras at home. Real men use protection and keep shooting. One of the easiest ways is to pull a plastic bag down over the camera and clip off the two corners to allow for the neckstrap. Cut a hole for the lens and duct-tape the plastic to the edge of the filter. Then operate the controls up through the open bottom of the bag. Should greater protection be needed during tornadoes and the like go for one of the commercial housings such as an EWA or Ikelite, which are completely waterproof though somewhat clumsy to operate.

Bounce Protection

Apart from the sissies and tough guys, some cameras are owned, and abused, by klutzes. Some guys just seem to drop everything they touch. Sorry, no

advice. On the other hand, a substantial amount of damaged equipment results from failures in the carrying system. The weakest link is where the neckstrap connects to the camera. Begin with neckstrap rings that need at least two or three revolutions to become disconnected. Any device that goes on with ease will come off likewise; find one that takes a temper to install. Eyelets molded into the camera body, particularly brass ones, become worn with use. Make sure you check yours periodically and have them replaced when they start to look thin.

Wimps solve the problem by leaving their cameras at home.

Mini-Vac With a Mighty Slurp

One problem with most techniques for removing dust from camera interiors is that they don't work. The various brushes and blowers only relocate particles inside the camera. As far as I'm concerned the only cleaning device that's worth its dust is the Mini-Vac, probably the world's smallest vacuum cleaner (you can hold it in one hand) and surely the best design for camera interiors. It comes with interchangeable wands to access hard-to-reach locations and claims AC/DC compatibility. When you want to get rid of dust, don't just move it, remove it. I feel like I'm writing ad copy. Come to think of it, I guess I am. Write to Mini-Vac, Box 3981, Glendale, California 91201. And I'm not even getting paid for this.

Now don't get any ideas about using the house vac. I cautioned a belligerent friend against it and then watched him suck the whole shutter right out the back of his Canon F-1. I could hear a string of oaths hissing above the clatter of his titanium shutter fluttering through the vac's hosing.

Try a Little Trouble-Shooting

*Don't even
try to remove
it and if
you do, don't
say I
didn't warn
you.*

If your pictures are consistently unsharp, don't automatically assume that you have mechanical failure. There are several causes for improper focusing, some of which you can repair yourself.

The first thing to check, naturally, is the lens. If the lens will not focus on infinity (in other words, when the lens is focused all the way out and the split image does not line up) then you obviously have a focusing problem. But make sure it's the lens by trying another lens on that body. If the second lens focuses normally then you can assume the first lens is the culprit — probably caused by a loose internal element — and definitely in need of a specialist.

If the misfocus continues with various lenses, then the body needs help. First check the reflex mirror behind the lens. If the mirror is being obstructed by debris inside the camera it will project the image at an odd angle up through the focusing screen. Naturally there could be other causes for focus misalignment (such as impact damage), but check the mirror first.

Next inspect the focusing screen. If the camera was jarred or if the screen was moved somehow, that could be your trouble. See that the screen is not in upside down (yep, I did that once) or misaligned in the breech, both of which can easily throw off the focus.

The third possibility could be in the lens-to-body connection. If this coupling is damaged in any way, it could put the lens out of parallel with the film plane and you wouldn't be able to focus both sides of the frame at once — obvious in the viewfinder. Again this one takes a person with more tools, parts, experience, and patience than you and I have combined. Feel free to try your hand first though if you like. You'll see.

The mirror inside the camera carries one of those look-but-don't-touch taboos. The acid content in your fingers that I harped on earlier can actually eat tiny holes in the glass surface if it's not removed. Unfortunately you won't be able to remove your fingerprint without scratching the delicate surface-coated mirror. Don't even try to remove it and if you do, don't say I didn't warn you. A certified camera repair service will have to clean the mirror with a sonic bath.

This may take more tools, parts, experience, and patience than you and I have combined.

Feel free to clean your lens element (once in awhile anyway), but don't ever put the cleaning fluid directly on the lens. If it runs down the edge of the concave surface and comes in contact with the

One of the surest ways to check for focusing faults without sophisticated equipment is with a ground glass and magnifying loupe. There are four other diagnostic checks to locate the problem.

rubber seal, the fluid might eat through the seal and cause internal corrosion. Instead, apply the fluid to the tissue and then wipe the lens with the moistened tissue.

Okay, so you already knew that but did you know dust inside your viewfinder can cause under-exposure? Finders and metering heads are the most poorly designed compartments on the camera and do little to keep out dust, which most people ignore because it doesn't show up on their film. Little do they know. The dust causes refraction by dispersing the light inside the head and makes the meter high, I mean makes it read high. Essentially it deludes the meter into believing there is more light than what's actually the case, underexposing as a result. And that affects film if you ask me. Keep it clean.

This was such a good test I was of a mind to just steal it.

Self-Repair

Let's just say you do everything right, never drop your camera, never shoot tornadoes and one day (the first day the warranty expires, let's add) your camera dies, for no apparent reason. Time to see the friendly repairman right? Maybe. First might I tempt you into tinkering with it yourself? No? What if I supplied you with a manual that told where every screw was and how to change every circuit with ease? What if half the manual was devoted to sorting out the root of the problem complete with pictures and diagrams? And what if after you tried it out and failed you could return the manual for a full refund and then send the camera to the repairman? Maybe? Fine then. Here's where to get it — Ed Romney, Box 5247L, Spartanburg, South Carolina 29304. These are some of the topics covered in each manual available for most current camera models:

- tools and getting started
- taking the camera apart
- testing and adjusting shutters
- testing and setting focus on lenses and range-finders
- lenses and diaphragms
- 35mm wind
- meters
- single lens reflex
- rangefinder and viewfinder
- trouble-shooting electronic and mechanical cameras

To be fair I should add that some manuals are better than others. I ordered one for a Nikon Ftn and liked it. Joe ordered one for a Yashica-Mat and hated it. It doesn't cost anything to try, though, since Ed keeps his word.

Halt Vibration

If you and your camera travel together much you may already know, too well, that vibration in jets and cars can disassemble cameras faster than Marty Forscher can. A simple way to prevent this is to put a drop of fingernail polish with a toothpick on each exposed screw head, which will seal them in place, but can be chipped off anytime opening the camera is necessary. Sealing the screwheads protects them from moisture and corrosion as well. A more permanent alternative to fingernail polish is a compound called Loctite, available at automotive supply stores.

But beware. The hardness of the compound is coded by color like cross-country ski wax. Stick to blue. Other colors (according to Joe) will stay goopy or petrify your camera.

Great Grits

Ever get a speck of sand lodged between the lens barrel and the focusing ring? Don't lie, we all have. Next time you hear that nauseating sound try slipping a business card in the crevice and working it up and down until the grit is dislodged.

Inexpensive Camera Repair

I have a feeling we left a few folks back there at the "tinker" sentence — the ones who have trouble setting their digital watches. So for you who aren't up for doing your own repairs, there's Essex. At this time their price for a complete camera overhaul, including parts, is $25 to $36 for rangefinder cameras, and $32 to $49 for any single-lens-reflex camera. Call or write for an update at Essex Camera Service, 230 Patterson Avenue, East Rutherford, New Jersey 07073, 201/933-7272.

A Must

Now to be honest with you I don't really care whether or not you feel like fixing your own camera or want to try Romney's manuals or Essex or any thing else in this book. But one thing I insist on — if you own a camera you must own the following book: *An Introduction to Camera Maintenance* by Joseph Lippincott, available from Box 813, East Lansing, Michigan 48823. You can even get damaged copies for half price if you beg. But here's the

thing; you'll find tips there that you won't find else-
where — anywhere. For example, I'll pull out a few
items that I thought related to this "extending your
warranty" theme. In fact (I'm writing this after I got
them all down), they go on for four pages.

Detecting Light Leaks

When you suspect one of your cameras has a light
leak because parts of the film are consistently
fogged, here is a way to locate the leak. Cut a piece
of unexposed enlarging paper twice the size of your
camera interior, fold it in half (emulsion sides fac-
ing out) and place it inside the camera. Do this in
the dark, of course. Close the back and expose the
camera to a bright light source. Then process the
paper and you'll see exactly where the light leak is,
X-rayed onto the paper.

*I ordered
one for the
Nikon Ftn and
liked it.
Joe ordered
one for a
Yashica-Mat
and hated it.*

Gunk Removal

If you tape up your camera with duct tape as sug-
gested earlier and then later decide to peel it, you'll
discover a residue on the order of soft bubble gum
covering your entire camera. Not to worry. Wipe it
off easily with lighter fluid. [Author's interruption:
In my experience neither lighter fluid nor any of the
dozen other solvents I have tried work as well as
one called Cell-U-Solve, manufactured by Chem-
tech, which cuts through goop in a flash without af-
fecting the finish beneath.]

Unlikely tools to fix lens barrel dings, but they work!

Chipped Lens

Scratches, chips, or blemishes in the rear lens element will not necessarily affect image quality. The worst it can do is refract light passing through the lens. Painting the scratch dull black will minimize that effect.

You may get tiny teethmarks in your toothbrush, but I figure that's a fair trade-off.

Focus Test

Another method of checking lens/body focusing error is to place a piece of ground glass (such as a removable focusing screen) on the film track of the open camera. Hold a loupe magnifier up to the

ground glass, and with the lens set on infinity and with the shutter locked open, the image should be sharp. (It'll be upside down too so don't panic.) If it's sharp through the glass but not through the viewfinder the failure is located somewhere from the mirror up. This is such a good test I was of a mind to just steal it and slip it in, back there with my focusing failure tips, but it was Lippincott's idea, and he deserves the credit.

2000% Discount on Shutter Repair

Next try 180-proof alcohol. And if that doesn't work toss the lens and finish the bottle.

If you discover a pinhole in your shutter the camera repairman will start quipping about a new $200 curtain, if he doesn't just tell you to scrap the whole thing. Hogwash. Pick up some black Duro Plastic Rubber from your local hardware store and use your trusty toothpick to plug the hole.

Declawing Cameras

Scratches on your film? Take a new roll of film and advance it through the camera, then rewind it. Carefully look for powder traces on the pressure plate. Check the film for horizontal scratches (emulsion-side scratches are caused by the guide rails and base side scratches come from the pressure plate). Measure the location of the scratches on the film to determine where the burrs are located on the camera and remove them with jeweler's rouge or "blitz cloth" that GIs use to buff their buttons.

Killing Lens Cultures

To remove fungus from a lens try this. Mix ten parts of 3 percent hydrogen peroxide with three parts of 28 percent ammonia and apply to the lens surface. After several minutes wipe dry with clean lens tissue. Then clean the lens surface with distilled water and dry it thoroughly. Should that fail use 180 proof alcohol. [Author's note: And if that doesn't work, toss the lens and finish the bottle.]

New Bellows Below Cost

You can restore flexibility to aging leather bellows by applying Lexol or Neat's Foot oil with cotton swabs, or Armor-All vinyl renewer to vinyl bellows.

Lens Ding Removal

Everyone has at least one lens with a ding in the filter threads rendering it useless but not worth the price of having the lens barrel replaced. But it won't cost anything to repair it with an old toothbrush. First wrap the edge of the lens with duct tape to protect it. Then tighten a hose clamp (available at automotive supply stores) around the lip of the lens to retain its shape. Now place the lens on a fat phone book. Hold the curved side of a toothbrush handle on the bent lens threads and whack it with a hammer. Presto, straightened lens flange with unsmashed threads. Now you may put tiny teethmarks in your toothbrush, but it's a fair trade-off.

Well, Lippincott's book goes on and on with nuggets like these — simple answers to common frustrations we've always thought we had to live with. Not so, just read Lippincott. If you're not convinced yet, peek ahead in Chapter 8.

Holy Cow

And one more thing before you turn the page. Half of you (at least) will see the word "darkroom" and skip blithely on to the next chapter, somehow associating the word with the Dark Ages. But wait. Before you pass it by there is something you should know about cows, so read the first page before you abandon the chapter.

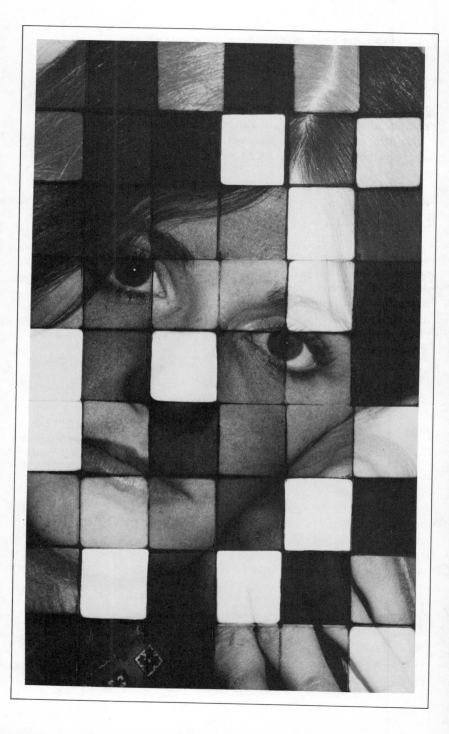

7

Darkroom Discounts

Half the joy and skill of photography is in the artist's interpretation of his film. So in my mind, the photographer without darkroom prowess is like a blind painter trying to delegate brush strokes. But shutting your eyes won't make darkroom expenses disappear, and they can outpace shooting costs in no time.

He's afraid it will nickle-and-dime him to death. Darkroom homicide— you hear about it all the time.

With the right approach, however, you can not only reduce darkroom expenditures to negligible proportions but turn the advantage around to decimate your filming costs as well. Then there is the added benefit of custom work that you can't buy for any price.

So why aren't more photographers doing it in the dark? Cattle grates. When highways began to bisect ranches out West, the cowboys needed something handier than fences so they invented cattle grates aimed to support auto tires but trip the bewildered animals. Eventually the cows tired of stumbling on barred surfaces and the ranchers grew

Darkrooms don't "take" money, they "make" money.

weary of building them. With their livestock thus educated the ranchers just painted stripes on the pavement. Sure enough, the ignorant bovines wouldn't even tiptoe across the imaginary grates.

By this point you're probably convinced that somehow the wrong page slipped into this book at the printer. No, we just have some imaginary cattle grates in photography that scare a lot of photographers out of the darkroom before they take their first step. One misperceived barricade is that darkroom work is difficult. Nonsense. At one time it required advanced degrees in chemistry and physics to get any results, but today even making color enlargements is reduced to a one-step process.

Another misconception is that you need a *dark room* to set up a darkroom. Not so. You can process film in the kitchen sink and make prints in a closet without water.

One widespread fallacy is that darkrooms take money. They don't "take" money, they "make" money, and can cost as little as $150 to begin with for a complete color/black-and-white lab.

The best one I heard to date, though, came from some cow-brained photographer who thought it took genius to succeed in the dark. I laid that question to rest by telling him *I* was a whiz in the darkroom and he immediately saw the light. If you're not yet convinced consider this: It's not as hard or messy to develop a roll of film as it is to bake the average cake. That I can promise.

To top it off, what most photographers fail to realize is that there is a huge safelight box full of tricks, efficiency tactics, and economy stretchers that save money and time — two synonymous factors in the darkroom, since spending one usually wastes the other. This chapter will lay all the best methods out in the open for you. Feel free to rummage through everything and take what you please.

New Chemical Life

One of the easiest ways to begin cutting darkroom costs is by making chemicals go further. How would you like to ruin mixed chemicals in a hurry? Store them in plastic milk jugs, keep them about half full, and leave them in a lighted room or by a window, preferably near heat. Of course, reversing all that will extend their working life. I just thought that putting it in the familiar mode would allow quicker identity and a longer-lasting deterrent. Opaque glass containers work better, and I like to keep mine in the basement.

I heard of one photographer who froze his chemicals solid to make them last indefinitely, but they would then, of course, require melting before use. I suppose if you froze batches in quantities that you use frequently, say in one quart containers, it might work well enough. Considering that certain powders must be mixed at 100 degrees and then brought back to working temperatures, the melt-down method may be more convenient in the end. Or better yet, why not freeze them in ice cube trays so you can simply pop and melt as many cubes as you need per job? Add a microwave oven to the system and you'll have fast, efficient chemistry that never deteriorates. Just make sure your guests don't help themselves to the wrong ice cubes or you may be credited with stiffer drinks than you intended.

Chemicals left in open trays will also deplete rapidly. A good solution is to cut pieces of cellophane or plastic to the size of your tray and float them on top of the chemicals when they are not being used. This will hinder oxygen from defiling (read: "oxidizing") the chemicals.

Stop the stop bath from turning purple prematurely with this trick. Most of the contamination oc-

Shutting your eyes won't make darkroom expenses disappear.

curs as a result of developer carry-over transferred by soggy prints coming from the developer tray. Avoid the mixture by immersing the print in the stop bath quickly — just dip it in and out — and let it drain in the sink rather than back into the tray. The time it takes the stop to drain from the paper is sufficient time to properly deaden the developer.

Quick Prints

Beginners waste more time in the darkroom by doing each print individually when it's so much easier to expose ten or 20 sheets of paper without processing and then soup them all at once. The trick is to make optimum exposures so there is little chance of overdevelopment if one or two are left in the developer too long. A color analyzer can give accurate exposures as will a less expensive enlarging meter, or for that matter an ordinary light meter.

You'll cut darkroom time by 50% and paper waste by 75%.

Just read the critical area of exposure, and with a little experimentation you can establish a conversion system equating meter increments to exposure seconds. An easy way, if your meter reads full seconds, is to adjust the ISO rating so that for a correctly exposed print the aperture on the enlarger lens and the exposure time match those of the light meter. Then just follow what it says for consecutive negatives and you'll cut your darkroom time by 50 percent and your paper waste by 75 percent.

Cut Paper Expenses

Large paper is less expensive proportionally. Buy 16×20-sheet boxes and cut each sheet of paper into

four 8×10 pieces. Or, better yet, buy a 30-inch by 100-foot roll and cut it down to size.

Darkroom Conversion

Do you want a darkroom but only have a bedroom? Convert it inexpensively by taping black garbage bags or used black backdrop paper over the windows. One photographer cuts gray foam rubber slightly larger than the size of his recessed windows and shoves the panels in place whenever he needs darkness. Don't think you need running water to set up a darkroom either. Put developing trays on a table and wash the prints in the bathtub after you've finished printing them all.

Darkroom Subs

A friend of mine who complains about not having a darkroom and borrows mine habitually says he can't afford one because he's afraid it will nickel-and-dime him to death. Darkroom homicide — you hear about it all the time. If you fear a similar fate these tactics may suppress your anxiety and expenses.

Free Graduates

In place of $5 graduates, slice the tops off a couple of Kodak Rapid Fixer containers, which are

marked in one-to- 28-ounce increments. Or just about any quart container will suffice by marking capacity levels on the side with a marking pen.

Getting Heat

When you need temperature-controlled solutions for color or archival black-and-white processing, try one of these free substitutes. Slip an electric heating pad in a plastic bag and duct-tape it shut around the cord. Place this under a metal developer tray and regulate the temperature with the pad's rheostat. When you need more than one tray controlled, swipe the electric blanket off the bed and do the same thing.

Fishy Business

Developing tanks that need temperature-controlled solutions can have it by way of a fish tank heater. If you don't have fish, let alone a heater, you can buy one at the local pet shop for less than you can at the photo shop.

Supermarket Supplies

Mass-produced kitchen goods can beat the dough (that was cheap, I know) out of costly photo industry products. For instance, several varieties of plastic-ware bowls or metal bake trays in an 11×14 size can be purchased for practically nothing compared

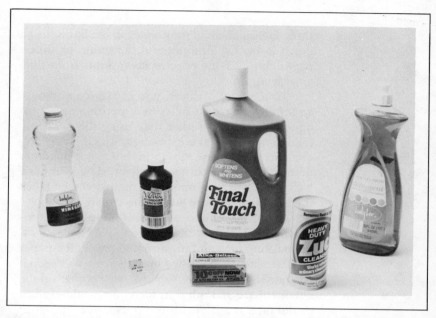

These supermarket items make great darkroom chemical substitutes and cost a fraction of equivalents purchased at photo stores. For instance, detergent is really Photo-Flo in bulk. Alka-Seltzer or Final Touch removes Spotone, and Zud dissolves developer stains. Vinegar makes cheap stop bath. Funnels cost 68 cents at the supermarket and $3.85 at the photo store.

to standard developing trays. Cooking funnels ring in at about one-tenth the photo store price but perform the same. Chemical mixers, rubber gloves, timers, graduates, half your darkroom equipment needs comes off the mass-market assembly line at one-tenth the price. Hit up the grocery stores once in a while and you'll sneer (or cry if it's too late already) at the price differences.

Zud — made for bathtubs — works.

No funnels for pouring chemicals? Clip off the bottom of a coffee filter and use it. And if you have a funnel but no wash tank, turn the funnel upside down over the sink drain and fill the sink with water. Water pressure will hold the funnel in place and drain from the upsidedown spout, keeping about

three inches of circulating water in the basin. Cut a notch in the lip, drill holes in the spout, or stick a paper clip over the edge to keep prints from clogging the drain.

In place of a timer, you can use a common wristwatch or clock, or even a metronome set for one-second ticks. Rather than using the switch on the enlarger to make exposures, which is not precise and could cause vibration, hold your hand underneath the lens, turn on the light, slide your hand back for the proper amount of time, and then block the light again before hitting the switch.

When you need but don't have a vacuum-mounted borderless easel you can get by with a little masking tape and resin-coated paper. RC paper lies flat, and double-sided masking tape will keep it positioned and secure. Tape off each corner on the enlarger base and rub your finger across the surface of the tape if at first it's too possessive with your prints.

When you need real big prints use pig troughs.

Then there are these suggestions stolen from Cora Kennedy of *Popular Photography*: Final Touch fabric softener can put the final touches on your print that got a little too much Spotone. In fact, Kennedy claims this solution works when the commercial dye remover won't.

If you run out of acetic acid for making stop bath, or just don't feel like paying for it anymore, use 5 percent white vinegar diluted 1:2 with water.

Tired of buying Kodak's Photo-Flo or similar overpriced wetting agents? Grab the liquid dish-washing detergent from under the sink and mix one-half to one teaspoon with 32 ounces of water. Even if you never wash dishes and have to buy a jug of the stuff you'll save about 80 percent over Photo-Flo.

I have tried several stain-removal concoctions, such as Edwal's Cleaner, at $5 a shot with zero results. Zud — made for bathtubs — works.

For stains on clothing I'd recommend something else that won't nibble holes through the cloth. Fixer and developer stains can be removed from colorfast fabrics with K-14 ($4) from Anchor Chemical Company, 777 Canterbury Road, Westlake, Ohio 44145.

Nose Job

You must be more wealthy or more wasteful than reading this far in the book would indicate.

Rather than trying to spot out a hairline scratch from a print, using Edwal No-Scratch beforehand on the negative makes a lot of sense and saves a lot of energy. But when you don't have a bottle of it handy, in a pinch, nose grease will do. Run your finger across your forehead or down your nose (no, no, I said *down* it) to pick up some skin oil and apply it to the negative. Oil diffuses the light passing through the negative, effectively hiding all but the biggest gouges.

Cheap Murals

It would take vast quantities of chemicals to process extremely large prints flat in open trays. But not if you use wallpaper trays or pig trays mentioned earlier. Some helpful hits: Skip the stop bath so you can get by with just two trays. Wash the prints in the bathtub or on the clothesline with a rotating sprinkler. Use RC paper — it develops and washes faster and requires no hypo eliminator.

Another option for making prints of a large size with a minimal amount of chemistry is with Maxwell Photo-Mural Tanks. These tanks are plastic tubes of various lengths with an innovative liner

rolled up with the print to allow liquid passage. More information and specific pricing is available from Maxwell Photo-Mural Tanks, 4559 Prairie View Drive, Riverside, California 92509.

I've always liked the idea of skimping on things I plan to throw away.

The key to the system is of course the liners, which are sold separately in order to facilitate successive printing. So I was going to suggest ordering just the liners and making your own tube out of PVC pipe (which could save you more than $200), but I decided not to because it's not right. It would be like you borrowing a copy of this book and photocopying it instead of buying it. I'm not worried about making such a suggestion, though, because it would cost more to copy the book than to buy it.

Skimpy Stripping

I've always liked the idea of skimping on things I plan to throw out anyway. So why use a whole sheet of paper for a test print, like Kodak suggests? Remember, they're the guys who make the enlarging paper, sort of like the suggestive toothpaste commercials where enough paste is used to gag a hippo. Granted, if the print has many contrast and tonal variances entailing several different times for dodging and burning, then perhaps an entire sheet or two are needed. But for most negatives a small strip of paper one-half inch by three inches (and they'll get smaller as you get better) is more than adequate to determine exposure.

The key to this strip technique lies in determining the most important area of exposure in the print. For instance, in people the tonal qualities of the face are most important. Therefore, note the location of the most important tonal range, turn off the enlarger light, and place your test strip precisely in that location. Then cover the test strip, turn on

the enlarger light, and draw the shield back in two-and-a-half second intervals for the maximum expected exposure time. Your test strip may not show an exact exposure using this technique, but it will be easy to calculate the proper time between the two closest intervals.

Saving My Rear and Your Prints

If the skimpy strip lets you down, don't tear up the print in a rage. It wasn't my fault. And just because a print is too light or too dark is no cause for pitching it (unless you are richer or more wasteful than reading this far in the book would indicate). The first thing you can do if the print is lighter than you expected is to leave it in the developer for about five minutes while you make additional prints. If that doesn't bring it up, put it in a bath of concentrate (undiluted) developer and rub it in. Rubbing creates friction, which speeds up the development process. Next try running hot water over the print while dipping it back and forth in the developer. If it's still too light — cuss me out and toss it.

If the print is too dark, set it aside and lighten it later with Farmer's Reducer or with a solution of bleach (potassium ferricyanide). This can also be applied locally to enhance specific areas. Now don't get the idea, however, that these are all just bailout tactics, because they can be used as valid fine-tuning techniques in normal processing as well.

Spotlight - Don't Spotone - Your Dust

Under the revealing illumination of daylight, many "beautiful" prints come out only to display an as-

sortment of lint and scratches that your handy Spo-
tone just can't handle. The sensible thing, of
course, is to have clean prints at the outset. Before
inserting the carrier, make sure your negative is
free of dust by holding it close below the enlarger
lens — this clearly illuminates dust particles.

*Always test
homemade light
sources or
any other
kind for
that matter.*

Safelights for a Buck

An inexpensive safelight arrangement can be had
by painting regular fluorescent tubes with red heat-
resistant paint. The tubes remain relatively cool
and will not blister the paint as an incandescent

*The best squeegees are free — discards from the family car. At least two dozen oth-
er household rejects can make fine photo gear as well.*

bulb would. But keep in mind that any safelight that's bright enough and exposed to paper long enough can potentially fog it. Always test home-made and commercial light sources before opening an entire box of paper in their presence.

Four-Dollar Darkroom Doors

Light does not bend, so one of the least expensive and most convenient ways to make a light-tight door is to hang three black curtains sealed on oppo-site sides and overlapping several feet apart. This adequately keeps out daylight, and you never have to open or close the door — or worry about some-one else doing it at the wrong time.

Believe it or not, there are limits to what I'll do to save a buck, but don't let that stop you.

Dust Defilement

Dust contaminates the enlarger, which in turn con-taminates negatives, which is then projected onto the prints, which goads the soul. In other words, if you want a contented spirit, you better start with the dust. Begin by carpeting the darkroom floor with indoor-outdoor carpet and keeping a plastic bag over your enlarger when you aren't using it.

Easy Enlargements

For a rather high price, many enlargers can be cus-tomized with longer necks that enable them to make bigger enlargements with less fuss. A better

way to get the same thing is to buy the less expensive model and mount it on a table with a leaf that drops down to various levels. In fact, you can make one from a half-sheet of plywood. Cut out a hole 30×40 inches where the enlarger's projected light will fall. Then tack one-by-two-inch strips on each side of the inside walls so the cutout section can be lowered. In this way you can make prints up to 30×40 inches (by projecting all the way to the floor) or any size in between simply by moving the board up and down.

Garbage-Can Processing

To tell you the truth I personally would rather have slides processed commercially for the convenience factor if nothing else. But I won't deny that you can save money by purchasing E-6 films in bulk and developing them yourself. It just seems too much like work to me, but if you must, here's how to make it easier and bring the cost down to $1 per roll. Start with a large plastic garbage can filled with water and either a fish tank heater or a darkroom thermostat. Next, purchase ten lengths of four-inch PVC pipe mentioned earlier and cement a cap on the bottom end. Stand these tubes around the inside edge of the water-filled garbage can and set to the proper temperature. Pour the chemistry for each step consecutively into each tube. Keep them in order since the tubes will not be moved.

Now thread all your reels of film onto a wire and lower them into the first tank with developer. Since no lids are used, processing must be done in total darkness and times read off the fluorescent hands of a timer or programmed on a cassette tape. At the end of the development time simply raise the whole string of reels out of the first tank and lower

it into the second and so forth for each step. Developer and bleach must be discarded after use; however, the other chemicals can be saved and reused up to eight weeks. Buy chemistry in bulk quantity for even greater savings and develop ten or 20 rolls at once. You'd never catch me doing one or two rolls at a time. In fact, these days you wouldn't see me doing any at all. Believe it or not there are limits to what I'll do to save a buck, but don't let me stop you.

The concoction stinks like ten thousand cornered skunks, but it works.

Erasing Chemical Stains

I used to throw away prints that turned up with those wretched purple developer stains. But I've learned that stains on bromide paper can be erased by washing them in a solution made from 250 milliliters of potassium aluminum with six milliliters of hydrochloric acid concentrate. Immerse the print in the solution and when the stains disappear, wash the print for ten minutes in running water. Developer stains on other papers can often be removed with ordinary vinegar.

Bleach stains require a similar treatment with a different brew. First try to erase them by refixing and rubbing the fixer in by hand. Failing there, make up a solution of eight ounces reconstituted lemon juice in four ounces of Kodafix concentrate and 20 ounces of water. Apply the solution locally with cotton swabs until the yellow goes away, then wash. Warning: The concoction stinks like ten thousand cornered skunks, but it works.

Speaking of bleach, one problem with using it on coated papers is that it tends to bead up and cause overbleaching. Get more even results by adding a few drops of Photo-Flo to the bleach.

Controlling Contrast

The whole idea of doing your own darkroom work is that you can beat the machine and salvage negatives and prints that would otherwise be wasted. If your negative has too much contrast, make a contact print onto continuous-tone film and sandwich the two negatives when making the print. This will reduce the difference between high-contrast areas, revealing more detail in both shadows and highlights. Your photo dealer will help you select the proper materials.

If you're using the lowest grade paper (I'm referring to contrast grade here, not quality) and still have too much contrast, try putting a piece of tracing paper in the filter drawer. This will lower the contrast by about one more grade.

On the other hand, when you're after more contrast cut a small hole in a piece of black cardboard and fit it below the lamp inside the *cold light* enlarger head. This will give you a harder quality light, thus increasing the contrast.

Negative Revival

Making bad negatives perform well is another ability of the darkroom photographer. More often than not it's easier and less expensive to fix negatives than to reshoot everything, so here are some ways to salvage botched negatives: First, if you overexpose or overdevelop and the negatives are too dense, you can thin them back to standard density by using a solution of Farmer's Reducer. Start with ferricyanide diluted to the recommended quantity, soak the negatives in the solution for five seconds, and then rinse them in clean water. If the negatives

are still too dense, repeat the procedure until the desired density is achieved. Should you have no idea what "density" to "desire" use this sentence to check. When a negative with proper density is placed on this page, the print should barely be legible through the densest areas of the negative.

If you have one of those priceless negatives that you'd gladly trade an arm and a leg for less contrast, wait. Before you start dismembering yourself try doctoring the negatives with a proportional reducer that dissolves more silver halides from dark areas on the negative than it does from light areas. It works pretty well, and it's painless.

Even if your negatives are overexposed or underdeveloped and look too thin for adequate printing, don't do anything rash quite yet. You can return them to average density by using a chromium intensifier. Immerse the negatives in the solution until they become bleached yellow. Remove the film, wash it, and then put the film in a solution of developer for five minutes, which will increase the density back to normal. Finally, the negatives must be washed and dried again. Easier done than said — almost.

You won't believe it until you see it . . . and even then you may not.

Color Correction Too — No Lie

Black and white is one thing, but what if I told you density reduction and intensification was also possible with color slides? You'd probably call me a liar or at least accuse me of exaggeration, but wait till you hear this. With the Kolor-Kontrol Kit, already-processed Ektachrome slides that are underexposed can be corrected by as much as two stops, highlights can be brightened, local areas reduced (as in cases where the difference between sky and

foreground is too great), green extracted from slides made under fluorescent lighting without filtration, cyan or magenta reduced by as much as 40cc without affecting other color values or D-max, and virtually any color intensified either locally or overall. Not likely you say?

They may sqwawk but I don't mind mentioning them since competition always has a way of forcing lower prices and better products.

Each kit makes one or two gallons and sells for $7.50 to $40 depending on the needed correction (each calls for different potions). But when you have a slide that really needs saving, ten times that price of your color film development (and who does Kolor-Kontrol, Box 50492, New Orleans, Louisiana 70150, and ask for their literature explaining the processes. No matter, you won't believe it anyway until you see it . . .and even then you may not.

An alternative is the reducer Colorbrite Overall from Special Products Labs, 4531 N.E. 11th Avenue, Fort Lauderdale, Florida 33334, which reduces density in Ektachrome films. Competition always has a way of forcing lower prices and better products, so I'm all for it. That is until someone copies my ideas!

Wandering Darkrooms

Photographers who can't afford to build a darkroom or who move so often it wouldn't be worthwhile should go portable. And why not? People do it with potties, TVs, even entire homes. All of which makes movable darkrooms seem sensible if not downright fashionable.

First off, you can make your own collapsing — I mean collapsible — darkroom by sewing a seven-foot-high box out of black curtain material. The door only needs to be three overlapping flaps. Hang it by the four corners to the ceiling and tape

the bottom to the floor with duct tape. It can be set up anywhere and stuffed in a cardboard box when you move.

I'm aware of the I-hate-to-sew members of society and they can buy one of these ready-made darkies for $375, which is a lot less than plywood and caulking would run unassembled. An even greater savings if you hate hammers too. It's made of vinyl 82 inches high by 64 inches deep and 64, 96, or 129 inches wide. Write to Photographic Equipment, 9071 Metcalf, Overland, Kansas 66212.

With portable potties, TVs, even homes, why not a portable darkroom?

Take Another Peek

Many prints are ruined because the darkroom is too dark and the print becomes too light, or other slight faults go unnoticed in the dim light. Remedy the situation by installing an additional safelight above the developing tray with a foot switch. In this way you can make spot checks of the print while developing it.

Home Brewing

Mix your own darkroom chemicals from powder stock rather than premixed packages and you'll shave 36 percent off the cost of developers and fixers. An added advantage is that you can store large-capacity powders in small areas (powder outlasts liquids by centuries) so you'll never run dry, so to speak.

Most black-and-white or color processing chemistry can be ordered in powder from Zone V, Box 811, Brookline, Massachusetts 02147. They'll

send you a copy of their full catalog and newsletter free of charge.

Guess No More

Quit wasting time and paper on test strips, to say nothing of botched prints due to misinterpreted guesses — pick up the Darkroom Computer for $10. This slide-rule-type contraption provides precise information to alter printing exposures, changes in magnifications, lens openings, paper speeds, contrast changes, and more. It can be ordered from f/22 Press, Box 141, Leonia, New Jersey 07605.

The high-tech junkies who stashed their slide rules along with longhand arithmetic at the first sight of calculators and who wouldn't think of ordering such a Stone Age device are probably reading the wrong book. Nevertheless, better than wasting more prints, buy the inexpensive Photometer, which, with the touch of a button (is that what you're after?), will indicate the best exposure, paper grade, or filtration. From Cybex, Drawer E, Pennlyn, Pennsylvania 19422. It should help prevent your darkroom budget from withering, but regrettably won't do the same for your brain.

Filter Alternative

Rather than spending $34 for a set of polycontrast filters, why not purchase the Ilford multigrade set of flexible polyester printing filters for $12.30? These can be cut down to fit most any enlarger. If

your enlarger does not have a filter tray you can place the gelatin filter on top of the negative carrier before lowering the enlarger head.

A Negative Theory

I've always subscribed to the theory that it makes more sense to modify the print than the negative when you have the choice. However, many photographers do not realize that soft focus, fog effect, low contrast and other special film effects can be added to prints, leaving the negatives straight. Check at your local dealer or write to Tiffen, 90 Oser Avenue, Hauppauge, New York 11788.

It should help your darkroom budget from withering, but regrettably won't do the same for your brain.

Eternal Developer

The cheapest, and some say best, developer around — and it's been around since 1891 — is Rodinal, which currently sells for $3.95 a jar. However, the real savings comes from its concentration, which calls for 100 parts water to one part Rodinal. At that rate it seems the little bottle lasts for centuries. Well, one anyway. Write to Agfa-Gevaert, 275 North Street, Teterboro, New Jersey 07608, and try a bottle — the last you may ever need.

Free Print Dryer

Remember all those aluminum screens that are replaced with storms every fall and do nothing but

take up space in the garage? Drag them into the darkroom for print drying screens. Place the prints in checkerboard fashion on the first screen, cover them with a second screen, and shift the pattern so air can filter up through the offset prints. Keep the pile going as high as you dare. Four-foot screens will allow more than 200 8×10s in a moderate-sized stack. You can even speed up the drying time by draping a sheet over the whole mess and shoving an electric hair dryer under the pile.

If you don't wash the screens first you may have to wash the prints later.

Prints Last Forever (Or Do They?)

Using powder you'll never run dry, so to speak.

Find out for sure exactly how long your prints and film will last (especially with all these dubious shortcuts I've been suggesting) with the Phillips Testing Kit. There is no point in saving money if you end up cheating yourself. The PTK makes sure you don't. It measures any residual chemicals left on the film or paper, which are the primary culprits of deterioration. In five minutes you'll know the life expectancy of your materials before it's too late to do anything about it. Order from Phillips Process Company, 192 Mill Street, Rochester, New York 14614. You can check up on your local lab when you finish auditing your own methods. And don't for a second think commercial labs are failsafe.

Easy Dodging

Some paper is lost because so much intricate dodging is required to get a perfect print. If you make

Risky as it may seem, double loading similar films, back to back, will cut your processing costs in half. There is a failproof method, though.

regular prints from a difficult negative you might get ahead painting selected areas of the negative with croceine scarlet dye, which will hold back light from those areas. The dye is diluted 25 percent and applied to the nonemulsion side; the more dye the more dodging. It all washes off if you botch up the first time around.

The cheapest developer around — and it's been around since 1891 — is Rodinal.

Blix Blitz

When color printing you can make the blix go about four times as far by first immersing the print in black and white stop and fixer before sending it to the blix bath.

Silver Saver

Like it or not the cost of silver will continually rise,
affecting all our film and paper prices. That's noth-
ing you can change, but you can benefit by it if you
recover what silver is left behind by your photo-
graphic processes. One of the least expensive re-
covery systems available is the WoogCell Silver Re-
covery Unit priced at $44.95 and available through
Helix, 325 W. Huron, Chicago, Illinois 60610. It
will pay for itself many times over. In fact, a friend
of mine circulates to all the local dentists and en-
gravers and offers to extract their silver from X-ray
chemistry and development tanks. He's laid up a
small fortune in solid bricks of silver.

Super Soup

They swear by it. Optimum Foto Products has re-
leased a new chemistry pack they claim will develop
negatives without the use of any water. Imagine
that if you can. The chemicals can be used any-
where from 60 degrees to 85 degrees with no time
compensation. What's more, different films, such
as Tri-X (rated at 400 or 2400) and Panatomic-X,
rated at anything, can all be processed at once with
no variation in time or temperature. One time —
eight minutes — fits all, and four ounces will re-
portedly develop 50 rolls of film. Well, I'm a gull-
ible guy and all that, but just the same I think I'll let
them talk their way out of that one. Write to Opti-
mum Foto Products, 13531½ Alondra Boulevard,
Santa Fe Springs, California 90670, and press them
for the truth.

Gifts Galore

When you want more control over the quality and price of you color film development (and who does that omit?), do it yourself for $1.25 a roll. Unicolor offers a starter kit at $4.99 that will allow simple home processing of four 20-exposure rolls of color negative film in 13 minutes. Ask your dealer or better yet, order it directly from Unicolor Division Photo Systems, 7200 W. Huron River Drive, Dexter, Michigan 48130. Here's why:

When you order chemistry directly from Unicolor they'll send you a free exhibition paper book that deals with paper characterisitics, exposure, processing, print finishing, storage, and the like. Then while they're in the giving mood, they'll throw in samples of the newest exhibition-quality paper. As if that's not enough, should your order be $20 or more you'll also receive a free bottle of black-and-white cold-tone developer. Use these catalog numbers when ordering: tray 100-60-0411 and K-100-35-0491.

If you really feel greedy you might also ask for their excellent newsletter called *Facts*, which is filled with even more cost savings darkroom tactics month to month. Then there's this other freebie . . . Oh, never mind.

Costly Water

That one natural resource that was always meant to be free is no longer. With more towns running dry every summer and the rest of them paying more and more for what they can squeeze out of the ground, extravagant continuous-running washes

are quickly becoming a luxury of the past. Shame on you if your washes aren't and listen up. Here is the economically preferred method of washing prints in this nuclear age. Use a Rapid Fix minus the hardener for two minutes with RC papers and soak ten 8×10-inch prints in two liters of water agitating constantly for two minutes. Do not use more than ten prints per bath. Next soak the prints in a freshwater bath for an additional two minutes, agitating periodically. And that's all you need to wash RC papers adequately and save the world hundreds of gallons of water.

It all washes off if you botch up the first time.

The skeptics of the bunch, and those still using paper-base papers, can avoid outlandish water usage by purchasing Ilford's Ilfobrome Archival Wash Aid that neutralizes the byproducts of fixing and cuts archival wash time to 23 minutes.

Half the Chemistry

In an emergency when you don't have enough chemistry to cover all your rolls of film (eight ounces per 35mm roll) you can get by on less — way less in fact. Just turn the tank horizontally and roll it back and forth throughout the development time or place it on an electric drum roller base. Don't bother to agitate — it'll get plenty of that on its own.

Two Prints for the Price of One

So you can develop two rolls of film for the price of one and here's a way to do the same for prints. Arga Photo Chemistry Extender is a simple additive that makes any paper developer last twice as long so you

get ten prints for the price of five, or 200 for 100. How can you go wrong? Write for more information to Arga Photo, Box 651, Orangevale, California 95662.

Fixer Test

Sorry, but I have no tricks to make fixer last longer. However, many photographers unknowingly dispose of fixer long before it's used up. When in doubt try this: Dip a section of film, such as the leader of the film you plan to develop, in the fixer and time how long it takes for the film to become clear. Double that time and that's how long you should fix that film in that solution.

Unmounting With the Greatest of Ease

One of the virtues of dry mount tissue is that once it's sealed it never comes apart — not even when you want it to. Before you try peeling the paper apart, dunk the mounted print in acetone or toluene. The solvent will not damage the paper but will dissolve the mount tissue in about an hour, after which the siamese prints will separate willingly. A warning to anyone who tries this one: Toluene fumes are toxic and acetone is easily ignited. If you die, this footnote should salvage my neck.

Ever try canning chemicals for a longer shelf life?

Continuous Darkroom Tips

If you liked what you picked out of this chapter you'll love what you can comb from Dale Neville's

Superformance Bulletin, known more affectionatly by his readers as *Superbull*. The monthly newsletter is a compilation of current and ongoing official and unofficial formulas for color processing as well as tips on methods and money-saving approaches. To give you an idea of what sorts of tips it contains, I heisted a few with Dale's permission and will list them below.

Developer Preserves and Other Inedible Darkroom Bits

Ever try canning chemicals for longer shelf life? Select jars with straight sides and pour paraffin wax on top of the chemistry after it's prepared. To use, push down on one side of the paraffin lid and pour out what you need. The paraffin will ride down with the chemistry sealing out air as it descends. For further protection, paint the side of the jar black with a strip masked off down one side to see the fluid level at a glance.

About Those Juice Bottles

Many writers in the consumer photo mags have made an issue of never using empty beverage bottles for photo chemicals, on the theory (apparently) that children will drink anything they find in such a container. I can only assume those writers keep their chemicals in the kitchen (perhaps in the refrigerator) and can't be bothered to educate their children.

If they aren't old enough to be made to understand what's drinkable and what isn't, they aren't old enough to get their own drink. That's just my wild-eyed opinion, of course. Ignorance of the hazards is the greatest hazard; and kids aren't that dumb, in my experience. But their parents aren't always bright enough to teach them.

Have Kodak Rapid Drum Users Been Suckered All These Years?

Kodak Model 11 drums have a lot going for them — instant start-up and instant shutdown, but their specified chemical volumes (four ounces per 8×10) are absurd. If you keep the drum level, less than two ounces will do just fine. Kodak's insistence on EP-200 developer is a mystery too. Zone V and EP-2 developers work just as well.

Rock-a-Bye-Tray

Tray developers have long resented the constant agitation needed in each step of their processing. The first way to simplify the procedure is to make a platform out of sealed plywood large enough to hold all trays at once. Tack a wooden or plastic strip one-half-inch wide down the length of the board. Then by tipping the platform forward all trays receive agitation simultaneously. That's a start, and you can always automate the platform if you really get lazy.

You can always automate the platform if you really get lazy.

Free Film

In this issue of *Superbull* there was even an offer of free bulk film (100-foot rolls of Ektachrome EPT, EPY, EPD and others) with the purchase of various darkroom accessories that were being sold at great discount through the bulletin.

Ignorance of hazards is the greatest hazard.

Neville says the brightest thing in your darkroom should be you and his newsletter will turn you on every month — get the *Superbull* by writing Neville at 153-A Thurston Avenue, Kenmore, New York 14217.

Making use of darkroom remedies not only improves your batting average with the camera and bank account — however sweet those may be — but ultimately it heightens the quality of your photos, and that's the heartbeat of this hobby.

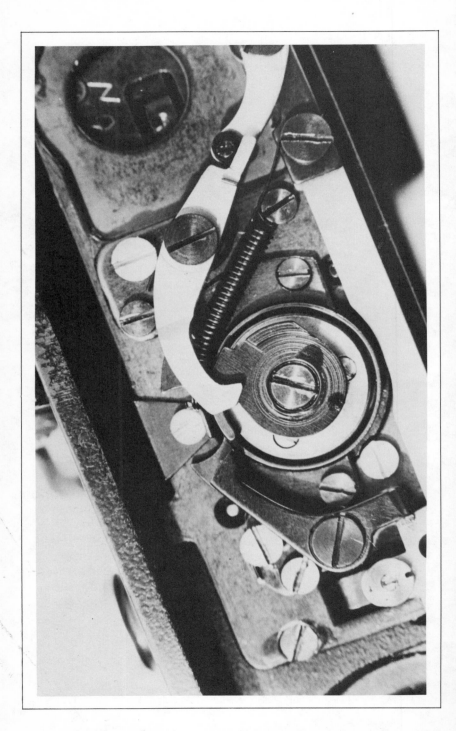

8

Camera Modifications

When reduced to primary objectives some photographers only want snapshots of the kids, others prefer recording news or history, some like to make money with photography, but none enjoy spending money on it. Unfortunately, regret does little to reduce the soaring expenses that stifle this hobby.

On the other hand, there are quite a few home modifications and adaptations anyone can do to make his equipment go further, last longer, and work more efficiently. Most of them take a little dexterity but little cash outlay.

Unfortunately, regret does little to reduce the soaring expenses that stifle this hobby.

You'll Love This One

Most photographers already know of him, and most of the biggest photographers depend on him.

One simple modification made to your photo equipment's extension wiring will make it infinitely more flexible. Amputate the heads and tails off all your electrical wires (except the ones that connect to the camera or accessory). This should include extension flash cords, remote trigger wires, accessory battery pack cords, basically anything with an electrical cord. Replace the connectors with standard electrical plugs and sockets, making them all interchangeable. Then carry one 30-foot extension cord in your gadget bag and any time you need an extra length, the one cord fits all. Or if you're on location and the flash head positioning isn't quite right, ask to borrow a standard extension cord and plug it in. With such versatility you can keep adding cords until you achieve any distance you want.

And one other thing. Try buying a 100-foot sync cord at the photo shop and you'll feel the real advantage materialize in your wallet.

Interbreeding Cameras

A lie encouraged by all camera makers is that once you buy into a system you have to use system lenses or the off-brands. Not so. Anyone can adapt a Leica lens, say, to fit a Nikon body or any other combination you desire. Most often it's the pro who needs some exotic lens not made by his company who simply buys the competitor's lens and has it converted. Not that it's always cost-effective, but it sure beats buying another body in order to use that one lens. Whatever the situation, just remember it's eminently possible to fit just about any lens to any camera. Many camera repairmen can make the

One way to standardize all camera cords is to attach electrical recepticals. Then any household extension cord fits all. Another trick is — on second thought, quit skimming the captions.

transplant; Marty Forscher is the best: Professional Camera Repair, 37 W. 47th Street, New York, New York 10036, 212/382-0550.

Camera Creations

Now that I've mentioned Marty I should add that in the field of camera modifications he is a living legend. So much so that I probably didn't even need to introduce you; most photographers already know of him and most of the biggest photographers in the country depend on him. If you need your camera to do something "it can't possibly do," Marty can

Try buying a 100-foot sync cord at the photo shop and you'll feel the real advantage in your wallet.

make it. You tell him the application and he'll devise the means. No, I didn't say he was inexpensive. I said he could make your idea functional while everyone else would scoff at the idea. And that's worth more than money. I suppose I should have put this at the end of the chapter with the heading, "If all else fails, call Marty." Well, try to remember to the end.

Lens-Reversing Adaptor

One of the easiest ways to make a lens-reversing adaptor is by modifying a standard body cap. Drill out the center core of the cap just to the inside of the flanges. You can do this either by drilling a series of small holes around the diameter, using an expansion bit the proper size, or cutting it out with a red-hot X-Acto knife blade. Smooth the cut with a half-round file and then with sandpaper.

Next cement a filter ring the same size as your lens to the front edge of the body cap with quick-drying epoxy. Make sure the threads of the filter are facing out. These rings can be purchased from your photo dealer or you can save and use the ring from a broken filter. And there you have it: a lens reversing adaptor for close-up photography that costs the price of a body cap and a broken filter. What's more, it will allow any lens with the same filter size to be used on your camera body.

Polaroid Backs . . . and Fronts

Once in a while every photographer has wished he had a Polaroid handy to check tricky lighting, a re-

mote set-up, or an unusual angle. Better still, we've all dreamed about a Polaroid back for our 35mm cameras so we can check the scene through the taking lens. Quit dreaming and talk to the folks at Four Designs, 9514-9 Reseda Boulevard, #616, Northridge, California 91324. They make Polaroid cameras that accept most brand lenses with reflex viewing and flash sync from one- to 1000-second shutter speeds.

Most of these modifications take a little dexterity but little cash outlay.

When you're setting up a critical fill-flash exposure or a slow shutter-speed pan, don't risk the image effect on chance. Take a quick test exposure with the Polabody, switch lenses, and fire away. That's one-upping Polaroid backs, where you must rewind the 35mm film or waste a sheet of Polaroid film every time you exchange backs. Various models are available ranging in price from $100 to $650, and all are approved by Polaroid. Four Designs will also modify rangefinder Polaroid cameras to reflex viewing and other innovations. They'd be delighted to tell you all about themselves.

Freeze-Out

Frigid temperatures get blamed for a lot of photographic crimes, not the least of which is battery strangulation. Some wintertime shooters disassemble their power packs and install auxiliary plugs so that the batteries can be carried in a pocket next to their bodies with a wire running out to the camera. If you are not electronically inclined I'd suggest letting Marty and his gang handle the implant. If you are, then you don't need me to tell you how, but essentially the idea is to solder two new wires onto the terminals leading to the battery chamber and install some sort of port to the exterior. On some cameras,

such as the Nikon F3, the light meter runs off the motor drive batteries when the motor is attached, making the bypass doubly effective.

This custom camera pack made to spec by Cook's Custom Sewing cost all of $55. Try to beat that price anywhere.

Homemade Camera Packs

But if pressed, I'd admit that's a lot of jury-rigging.

When gadget bags sell for upward of $350 it's high time to start reconsidering your craft skills. What's more, custom designs can provide features you can't buy. One of the most sensible camera bags I've ever used, and believe me I've used nearly all of them, is the converted daypack. It allows tons of equipment to be carried safely out of the way, leav-

ing both hands free. And they don't flop around your neck like an albatross. Finally, compare prices and you'll be easily won over.

Here's how to make one. Start with an ordinary one-compartment daypack available at sporting goods stores. Cut and glue pieces of closed-cell foam, also sold at camping stores, in the top and bottom of the pack. Then cut a piece of gray foam, sold at photo stores, to fill the whole interior of the bag. You can cut the stuff with scissors or a razor or tear it apart with your teeth, but the best method is with an electric meat-cutting knife. If you really want to do a professional whacking job, moisten the foam and stick it in the freezer until it becomes partially rigid.

Once you have a tight-fitting piece of foam, remove it and arrange your various pieces of equipment on top. Trace around their outlines with a soft lead pencil and then cut out the holes going all the way through the foam. For partial depth, cut the plug at the desired height and glue it back in the bottom half of the hole. If you moistened the foam, dry it out thoroughly before gluing it into the pack with rubber cement.

And there you have a pack that will keep your photo equipment rain-, snow-, dust-, and bounce-proof. All for $25.

Go it one step further by ordering custom shells from Cook's Custom Sewing, 2145 Dickens Lane, Moundsview, Minnesota 33112. Well, they're hardly just shells. They make packs to any specifications from durable Cordura material and all exterior walls are reinforced with closed-cell foam. No matter how elaborate, the pack will probably cost less than a commercial one. I ordered one specially designed to hold two Nikons with motors and five lenses with quadruple stiching, five exterior pockets, four leather cleats, a sleeve to hold a monopod, padded shoulder straps, and large-tooth, double-di-

If you really want to do a professional whacking job, use electric meat cutters.

rection zippers on all openings. Price tag for the whole contraption — $55. Now if anyone knows where to beat that, you speak up right now . . .

That's what I thought.

Ammo Boxes

It will keep your equipment rain-, snow-, dust-, and bounce-proof. All for $25.

I didn't say you could hold one of those Cordura bags under water and expect no leaks. But if that's what you have in mind, stop by your local Army-Navy Surplus Store and grab a .50-caliber ammunition box. Make sure it still has a rubber seal or you might as well use a lunchbox. Line the inside with closed-cell foam, such as Ensolite (but not foam rubber), and your cameras will feel more at home. I think they're up to about $8, which wouldn't even cover the cost of the hinge if they were made today.

Hip Holsters

Anyone fairly proficient at dot-to-dot drawings should be able to stitch together a leather holster to tote lenses on their belt for quick and easy access. Start by lining up all your lenses side-by-side on a strip of leather as wide as your longest lens. At least that's what I did. Then cut out slots at appropriate locations for your belt and punch a row of holes between the lenses. Now take a second length of leather the same width but at least twice as long and stitch the two outside edges together. Sandwich the first lens between the leather strips and stitch them together with a leather thong. Then wrap the sec-

ond lens, and continue until complete. The last step is to cut and sew bottoms for each opening. Try it, your lenses will like it.

Remote Trigger Deluxe

I won't go into the applications of remote photography, but I could write a whole book on that in itself (perhaps I will). But in the meantime, trust me, nearly every person who owns a camera could improve his take with an occasional remote shot; that is, a picture taken far from the camera or with the camera positioned somewhere you wouldn't dare stick your nose. Single-advance cameras don't work too well because you can only get one picture. Auto winders are usually a problem too since they don't generally come with auxiliary outlets. One way around that is to fashion a clamp from a strip of metal with a hole drilled through one end. Bend the strip around the winder handle so the hole is positioned directly above the trigger. Clamp or tape it in place. Then screw a pneumatic air release into the hole. By squeezing the bulb the winder can be activated from a distance of about 25 feet.

But if pressed, I'd admit that's a lot of jury-rigging to gain a mere eight yards. It's just that some people can't stand poking holes in their cameras. The rest of you can do this. Hot-wire the motor by taking the case off and crossing each contact until the motor gives a little grunt. That's the key. Solder two wires onto each of those terminals and affix an exterior plug in the casing. Now insert a wire with any kind of momentary switch, like a doorbell switch, into your new socket, and by touching the switch you'll trigger the camera. Naturally you can do the same for motor drives by cutting the lead off

the factory plug and splicing your own cord into the two wires.

Now the fun begins. What can we use for switches? Just about anything that closes a circuit will do. The easiest of course is just crossing the wires, like we already suggested, and any kind of wire will do — speaker wire, lamp cord wire, antenna wire. (No. The clothesline wire won't. Well, come to think of it, I guess it would but you'd have to figure out a way keep the bare lines from accidentally touching between pictures.) Anyway, you get the point, and any old switch can be used to short the wires. Now, don't get wise again.

The setup above is called a "hard-wire," but once you understand that any circuit-closing device can activate the camera all sorts of deviate possibilities come to mind. For instance, you could steal the burglar alarm system out of the house and wire it to your camera. Any mechanism with a beam, such as sonar or infrared, can be positioned with the camera focused on the invisible line. Then anything passing through the "gate" will trigger the camera automatically. The application that first comes to mind would be to capture elusive wildlife or a bird at its aerie. Yes, I too thought of using it to photograph thieves entering the house, but I figured they'd just smash the camera and continue collecting — or the smarter ones would grab the camera too. Stick to wildlife, or sports that follow prearranged tracks.

Another good heist that makes a great trigger is the garage-door opener. In each case, to tap into the alternate device, locate the two wires that lead to the motor or whatever the switch is meant to control. Those are the wires that should go to the camera. If in doubt turn on the switch and cut one of the wires. The motor should stop. Another way to check, if you're not sure at all (and it's your dad's garage), is to attach the lead wires from your cam-

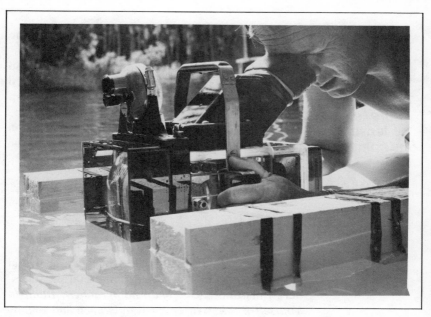

When the equipment you need doesn't exist, make it yourself. This underwater/topside housing designed and built by Burton McNeely carries a motorized Hasselblad and earned him $8,000 (so far) with the pictures from his first use.

era with alligator clips to the wires you suspect. Pressing the switch should close the door and fire the camera simultaneously if you made the right selection. All you need is the receiver (not the whole motor and crank) and the wireless transmitter. If the unit is battery powered — most aren't — you're in business, in which case you can convert it to DC before lugging it in the field, or use it near an outlet.

There's a better solution yet, however, if you need a wireless, lightweight trigger far from a wall socket. Use your electronic flash and a slave. Just mount the slave sensor on the camera hot shoe. Then splice the remote cord that usually connects the slave unit to the flash into the motor drive's remote cord. Now pop the flash and the camera goes.

The clean-up is easy — all you have to do is nothing.

Warning: Watch that the flash doesn't affect the lighting in your picture.

And the list is endless. You can use household light timers, darkroom timers, radio-controlled model-airplane receptors, electric-eye door openers, foot switches or even windup alarm clocks. The trick is to think backward. Start with the situation and then come up with a trigger that will best fit the application.

Here's an easy way to mate Leica lenses to any camera.

Here's More

If you like the idea of making your own gear that can serve you better than commercial products, here's just the book. *The Photographer's Build-It-Yourself Book*, written by Tom Branch and sold by the Popular Photography Book Club, Box 2003, Lakewood, New Jersey 08701. They say you can have it for $1, but I'm sure there's a noose somewhere.

The Semi-Tough Camera

If you're into outdoor photography, and even if you're not, here are some ways to beef up your camera to take hard use. Begin by amputating the camera's Achilles' tendons. Ditch the leather case, the factory neckstrap, the eyelet rings, and the lens caps. Invest in a wide adjustable neckstrap, heavy-gauge eyelet rings that need two complete revolutions for connection, and neckstrap protection shields.

Next paint the chrome edges with fingernail

polish and cover any other exposed edges with black duct tape. Use lens shades on all lenses to provide front-end protection and reduce light refraction. Dab the heads of all exposed screws with fingernail polish. If your lens is not made with a rubber focusing barrel, purchase an auxiliary rubber grip or make one from a bike innertube. A rubber eyecup will protect the backside of the camera and give a brighter viewfinder image. Thus armored you can keep that camera firing out on the lonesome trail.

Lippincott Wizardry

If you are inclined at all to making your own camera modifications, I'd once again (as promised) recommend Joseph Lippincott's manual *An Introduction to Camera Maintenance*, available from Box 813, East Lansing, Michigan 48823. And just so you won't think I'm shoveling some vested interest I'll tell you what's in the book. Well, part of it anyway.

So I bought a plastic housing and performed delicate surgery with a hacksaw and blowtorch.

The following are a few items I found in one section called "Modifications": Pre-1964 Nikon F cameras will not accept the newer Ftn metering finders. That is unless you remove the engraved Nikon nameplate under the viewfinder and bevel both front edges. Replace the two screws and try the new finder. Such an upgrade will increase the value of the camera considerably when sold as an Ftn rather than an F.

Lippincott tells and shows (the book is more generous than this one in pictures and diagrams) how to modify a Nikon motor drive to fit a Minolta SRM body as well as how to restructure other brand motor drives to make them more versatile and balanced with long lenses.

Here are 15 easy camera modifications that can make a soft camera hard: 1. Toss your leather case. 2. Duct-tape exposed edges. 3. Use Mylar as a substitute. 4. Coat chrome edges with fingernail polish. 5. Replace neckstrap eyelets with heavy-duty type. 6. Replace batteries once a year. 7. Keep clear filters on all lenses. 8. Use a wide neckstrap. 9. Put extra layers of duct tape on the bottom of the camera. 10. Invest in a rubber eye cup, which has three good functions. 11. Seal exposed screw heads with fingernail polish. 12. Use sunshades fanatically. 13. Install a rubber focusing barrel grip. 14. Keep shutter released. 15. Keep the exterior of the camera clean.

The problem with Leica CL cameras is that both neckstrap eyelets are located on the left side of the body, sort of like the eyes on a flounder. As a result the camera hangs vertically. Adding an eyelet from a Nikon to the right side is easy and allows the camera to hang the way it should.

A slave to trigger either the motor drive or an electronic flash can be made from a LASCR unit available from Poly Paks, Box 942, South Lynnfield, Massachusetts 01940, or Chaney Electronics, Box 27038, Denver, Colorado 80227. The unit has three terminals. The right prong (farthest from the reference tab) goes to the positive lead. The other outside contact goes to the opposite or negative lead. The center terminal goes to a 4,700 ohm resistor and back to the negative lead. Plug this into the flash or motor drive and any burst of light will trigger it. Lippincott mounts the tiny LASCR in the end of an electrical male plug and simply inserts the plug in his Nikon F-36 motor drive for remote triggering.

You can buy standard flash adaptors from most photo supply stores and plug them into the Leica M-locking nipples to make the camera compatible with any flash unit with a PC cord.

Here's an easy way to make Leica lenses, which are known for their acuity, mate with other cameras. First order an "A" ring from Leica, but don't tell them your intentions. The ring is made for copying and has a Leica M-bayonet in front and Leica screw thread in the rear. Also order a short Leica screw-mount extension tube in the 7–15mm range plus a T-mount adaptor for the camera you'll be using. Assemble this menagerie between lens and body and you'll be gazing through Leica optics on your any-old-body.

On most 35mm SLR cameras, like the Nikon F, a sponge strip at the top of the mirror box dam-

pens the impact of the blinking reflex mirror. In time, of course, the cushion grows tired of being punched and wears out. A convenient, if only temporary, replacement for the sponge is the felt lip peeled from an ordinary 35mm film cassette and cut to the right length. Rubber cement will keep it in place.

And while you're monkeying around with your camera you may come upon a screw that won't give. Place a drop of hydrogen peroxide on it for a few minutes and it should surrender.

The book is jammed with these sorts of tips but I dare not steal any more. You could though, if you had a copy.

In the end it doesn't really matter where you obtain assistance, but it helps if you realize there's almost always a way to get what you want. Too often our mentality limits us to think only in terms of what the cameras were designed for. Better to start with the picture you want and then come up with the needed equipment, whether or not it exists.

A good example is the time I wanted to take pictures of a windsurfer with the camera mounted on the sailboard. I was told underwater housings with remote triggering capabilities were not made. So I bought a plastic Ikelite housing and performed delicate surgery with a hacksaw and blowtorch until I had a remote underwater housing. I got the picture, mainly because I wouldn't take "no" for an answer.

The point is, don't limit your creative ideas with the excuse that your camera can't do it. Chances are it can. And if it can save some money in the process, all the better, but the real issue is that modifications can make your equipment outperform standard designs.

And remember, don't forget Marty.

9

Fifty-Four More Ways

I know you skipped to this chapter first, so I'll make my introduction here. This book is a compilation of tricks of the trade, a few ideas that have never been in print before, and age-old techniques that pros have been using since year 0. In other words, they are simply scattered thoughts on how to best economize time and money in photography while maintaining superior results.

Big savings come from little savings— made consistently.

The problem with writing such a book — one of the problems anyway — is that everyone reading it is at a different level of accomplishment. There undoubtedly will be basic information in this chapter and others that you have known all along. But the guy behind you might think it's the greatest innovation since the SLR. When should I hold my tongue and when should I let it run to keep everyone happy? My idea is that it doesn't cost you much to skip over a familiar paragraph, but it could cost the other guy hard-earned cash if we assume he knows something he doesn't.

So relax, take your waving finger out of my face, and breeze through this chapter, which amounts to a catchall linked only by the singular goal of saving you money.

Beattie's Bright Idea

The static charge causes dust literally to leap off surfaces.

One of the true advantages of super-fast lenses, whether you ever use them wide open or not, is that you always have a brighter viewfinder to focus through. But bright lenses cost big bucks. Here's a way to boost all your lenses up to four stops brighter, even if they are already the fastest. Replace the focusing screen with an Intenscreen made by Beattie Systems, Box 3142, Cleveland, Tennessee 37311, 800/251-6333. The-screen is made for all view cameras as well as Bronicas, Hasselblads, Mamiyas, and Nikons, and costs a fraction of the big lenses but provides one of their foremost functions.

Cut the Power and Double the Life

One studio photographer who makes heavy use of 3200-K floodlights discovered that by purchasing 3400 lights and reducing the color temperature with a voltage regulator he could extend the life of the lights by as much as 100 percent. It's easier to come by 34s than 32s, and you can always crank them back up if you need the hotter bulb.

Still, I doubt many photographers are into tungsten lighting, but I bet you use slide projectors. And with some of the current bulbs pushing $20 apiece, a few tips to extend their life might make up

for that last esoteric tip. The first cardinal rule is to keep your greasy fingers off the bulb. Insert it with a handkerchief or something else that doesn't carry human oil, which will create blisters (on the bulb, not your fingers) and lead to its eventual ruination. Of course, if you changed bulbs with your bare hands while the projector was hot you might get double blisters, but no one could be that ignorant.

Use the projector on the lower light setting rather than the higher level except when necessary, for obvious reasons. Don't move the projector after it's been run for any length of time, and leave the fan on for at least another five minutes after you turn the projector lamp off if you plan to move it right away. Otherwise it's better to turn the projector and fan completely off and let the lamp cool slowly. Always make sure the blower vent is not clogged with dust or other debris which prevents proper ventilation and overheats the bulb, causing it to die at an early age. When you travel carry the bulb packed separately (in rabbits' feet if you wish), and it may arrive intact.

Filter Falsies

Many photographers "in the know" like to keep clear filters on the end of all their lenses for protection. Where some go wrong, however, is by putting inexpensive off-brand filters on the end of high-quality glass. Such false filter economy defeats the purpose of going with superior optics, and in some cases is no better than shooting through the end of a Coke bottle. I suggest purchasing a systems filter. In other words, use Nikon filters on Nikon lenses, with the one exception being Hoya. Hoya filters are

inexpensive but are made with unblemished glass, and are available through most dealers.

How to Get Pink-Eye

We've all been in that jam where we had to shoot with available fluorescent light but didn't have the right filter. Next time you can sneak by (if you have to) using a No. 2½ polycontrast filter from the darkroom. Just tape it to the lens or fit it in a gelatin filter holder. Then everything will look pink as it should until the film is processed.

Emergency — or Just Plain Cheap — Tongs

When you need tongs in a hurry and fingers won't do, twist a wooden clothespin into cooperation. Pry the two halves apart, flip each side over so the straight handles come together and wedge the spring back on. The spring holds the handles (now the prongs) together, which are opened by pressing the opposite end — the part that used to hold underwear to the clothesline. They may be short but in a pinch they'll keep your fingers out of the soup.

Exakta, Exakta, Read All About It

Exakta owners, collectors, admirers, or simply wishful thinkers now have something to help them

dream — and scheme. A free newsletter catering to
the desires of all Exakta fans can be had for the ask-
ing from Exakta Camera Company, 125 Wilbur
Place, Bohemia (appropriately enough), New York
11716.

Dust Away

If you hate dust you'll love this: a genuine lamb's-
wool duster. But why wool? Well, according to its
inventor and all those hawking it thereafter (since
1854), most dusters only relocate dust whereas
lamb's-wool, they say, "actually attracts and holds
dust like a magnet. The static charge in lamb's-wool
causes dust literally to leap off surfaces (of enlarg-
ers, for instance) where it has accumulated . . ."
and so on. If you believe that, order one for $8 from
Tools For Living, 400 S. Dean Street, Englewood,
New Jersey 07631, 800/228-5505. If you don't be-
lieve it order one anyway and see for yourself, be-
cause if you're not satisfied they promise to return
all your money. And your dust.

*A light
table that
size would
cost $2,000.*

A Free 20-Foot Light Table

Once in a while you may need a giant light table to
sort through or organize a few thousand slides. In-
stead of staring out the window wishing for one, use
the window. Tape your plastic slide pages to the big
living room picture window and you'll be amazed
how many slides it can hold at once. No renting,
borrowing, or stealing required either. The only
catch: It keeps strict daylight hours (or you have to
stand outside).

Pay It, Sammy

If you sell any of your photography, or even if you just aim to, you can cut all your costs by letting Uncle Sam pick up the tab. Set up your own business and deduct all related expenses from the income tax on your regular job. Anything that has to do with your photographic ventures, including gas mileage, film, processing, repairs, a portion of your telephone bill, a slice of your mortgage, and anything else that is directly related to your taking pictures can be deducted off the top of your income and you will only be taxed on what remains. One word of caution here though: Sam's a nice guy, and blind most of the time too, but you can only push him so far. Eventually you will have to make more money than you spend on the hobby because two years out of a five-year period must show a profit, or he'll call your bluff. Personally I don't believe in giving him any more than I have to. Tax evasion is illegal, but tax avoidance is your prerogative.

Taxing Guides

If you're the paranoid type (you get nervous when you see a police car in your mirror), read for yourself what you can and can't get away with. Complete information on tax allowances and obligations can be found in two free publications at your local Internal Revenue Service: *Your Federal Income Tax*, Publication 17; and *Tax Guide for Small Business*, Publication 334. And that should keep the tax man off your back. I don't know what to do about the cops.

Selling Government Secrets

Then if you want to know about the loopholes the government *doesn't* want you to know about and other photographer's tax breaks, invest in the book *Selling Your Photography*, by Arie Kopelman and Tad Crawford. Both are attorneys, and Kopelman is a lawyer specializing in the problems of photographers. The book can be ordered from your local bookstore or directly from St. Martin's Press in New York.

More Tax Ammunition

And if that's not enough, here are a few more books and booklets to help you win: *How To Pay Less Tax* by Consumer Guide Publishing; *Tax Loophole Digest*, ULC Research; *The Tax Reliever: A Guide For Artists, Designers and Photographers*, Drum Books; *Photography and the Law*, Amphoto Books; *Photography: What's the Law*, Crown Publishers; *U.S. Master Tax Guide*, Commerce Clearing House; *Win Your Own Tax Revolt*, Harbor Publishing.

Then there are the loopholes the government doesn't want you to know about.

Do-It-Yourself Multimedia

Plans to build a tape-slide synchronization unit are available by writing The Millers, 1896 Maywood Road, South Euclid, Ohio 44121. The sync-box blends music, sound, and narration that can be used with any stereo tape recorder and has group circuits for multiple-projector and dissolve unit programs.

Is API for You?

To economize on photographic expenditures in several different areas, join Associated Photographers International. In addition to a monthly newsletter that shows you how to generate income from your photos (and how to create better photos, too), you'll receive a myriad of other benefits: cameras and lenses at low dealer net — "the lowest legitimate price available anywhere in the country"; up to 40 percent discounts on anything found in a well-stocked camera store (except film); a 25 percent discount on photo books, additional discounts on magazine subscriptions and other services; wholesale business aids, such as business cards and matching stationery, rubber stamps and pricing guides; access to a worldwide equipment protection program and an "all-risk" equipment insurance policy, as well as other full insurance coverages. API, 21822 Sherman Way, Suite 101, Canoga Park, California 91303.

The Cheapest — and the Best — Slide Dupes

The last time I checked, commercially duplicated slides were running more than a dollar apiece, and they look like they were copied by a blind man. You can lower the cost and raise the quality by doing them yourself. Many libraries, high schools, and community resource centers have slide duplicators like the Illumitron, available for public use or rental. The School Community Resource Center in Wheaton, Illinois, for instance, offers the use of their Illumitron and camera for one dollar an hour.

Marron-Carrel 35mm slide animation cameras cost plenty to buy but not too much to rent — and they work miracles.

Most units are calibrated for use with Kodachrome 25 film, and once the equipment is set up and focused it's just a matter of inserting the next slide and pushing the button. Of course, you can always set up your own system using a Spiratone Slide Duplication system or other devices that range in price from $55 to $169.

But when only the ultimate in quality will satisfy your needs, tabletop slide duplicating machines will not turn the trick. Imagine coming upon a duplicate slide that's as sharp as the original and can be enlarged to a 16×20 print or color separated for magazine reproduction. When placed side-by-side

What you really wanted to know about Cibachrome (but were ashamed to admit you weren't too rich to ask).

with the original the colors match so well it's impossible to tell which is which. Under closer inspection you'll notice that there is even more detail in the shadow areas of the duplicate, which somehow has less contrast than the original.

In a state of enthusiastic disbelief you quickly run through a few more comparisons scattered about on the light table. Here you find an original full of scratches, some completely through the emulsion but invisible in the duplicate. Next you spot a faded Ektachrome, apparently left out in the sun for too long. Yet the duplicate is full of vibrant color. Warped slides have been flattened. Some Kodachromes have been turned into tack-sharp black-and-white negatives, positives, and prints. You pinch yourself to see if you're awake.

What you have imagined is no fantasy — just an ordinary set of repro-dupes anyone can have. Expensive pin-registered cine-animation cameras are used to achieve these effects, but many professional labs will rent time on their equipment or perform the services at reasonable rates, particularly if done in quantity. Contact Marron-Carrel, 2640 W. Tenth Place, Tempe, Arizona 85281, or call 602/966-2189 for a commercial operator near you.

Prices to Make You Shudder

Every year more than 1,500,000 35mm cameras are sold in the U.S. According to *The New York Times*, nine out of ten American households now owns a camera. So if everyone already has a camera and new ones are still selling, all the "old" ones have to be piling up somewhere. A good portion of the stuff gets recycled through a paper called *Shutterbug Ads* (remember?), at prices I'd have difficulty convinc-

ing you of. Buy a copy or subscribe to the 100-page newspaper, which has a circulation of 70,000, and clean up on all the leftovers. Cost: $2 an issue, or $13 for 12. Call 305/269-3211, or write to *Shutterbug Ads*, Box F-840, Titusville, Florida 32780.

Free Ideas

A manual of special effects through filtration is available through Cokin. This booklet contains 158 examples of creative uses of filters and combinations. Write and ask for your copy of *Creative Photo Effects Manual*, A Color, 11037 Penrose Street, Sun Valley, California 91352. Sure, I'll admit most of them are gimmicks, but they're only free.

Know-It-All

Would you like to have a ready answer to almost any photographic question at your fingertips? Kodak's *Encyclopedia of Practical Photography* (available for a ten-day free trial) answers thousands of questions such as these: What are the six main kinds of lighting? How do you control electronic flash and auxiliary light? How many color compensating filters can be used together? How do you protect prints against color loss and change? How do most fashion photographers make their reputations? How do professionals judge print quality? What's the difference between high-density and low-density fog, and how do you adjust for it? What do advertising agencies look for in a photograph? What eight points should you cover in an assign-

All the answers are free . . . but you have to read fast.

ment to save yourself money and headaches later? Borrow it and read fast.

Saving Originals from Certain Death

If you market your photography for use in publications, you are well aware of the boneheads that handle our delicate materials. There's strong evidence that color separators are part-time meat-cutters and sometimes confuse which job they're working. To our rescue, or that of slides anyway, technology has recently provided several bypasses. One method used by many pros is to send out original slides along with a color Xerox of those slides, requesting the originals to be returned directly and leaving the Xerox on file with the editor. This allows him or her to see the quality of the originals and keep copies of them on file without keeping the original transparencies.

Most printers are part-time meat-cutters and sometimes they confuse which job they're working.

Another escape route is to make or have repro-dupes made that can tolerate the strict demands of publishing. Some photographers even have 4×5 dupes made of their 35mm slides to ensure adequate quality control. Repro 35mm dupes can be obtained from Comcorps, 7111 Fourth Street N.W., Washington, D.C. Commercial 4×5s can be ordered from Creative Color, 4911 W. Grace Street, Tampa, Florida 33607. Now before you send off 2,000 slides to each of these outfits let me warn you they're not cheap — they're good. The point of including them in this book is that for reproduction purposes you need the best.

Still another survival solution is to make Cibachrome or Agfa Speed contact sheets of the color slides and send only those. With the Ilford contact printing easel, 35 slides can be printed on one sheet of 8×10 paper.

If you are determined to send originals only, at least protect them in individual 2×2 plastic protectors. Some photographers and agencies go so far as to seal the edges and charge full reproduction rates if the seal is broken. Protectors can be ordered from Kimac Company, 478 Long Hill Road, Guilford, Connecticut 06437. Or save by buying 500 at a time for $25 from Heindl, Box 150, Hancock, Vermont 05748.

Top Catalogs at Bottom Dollar

When you're not sure what you want but would like to take a look at it anyway, don't ask the camera sales clerk, unless you want a funny look. You can browse till you're cross-eyed, though, in the following catalogs that probably cover everything worth considering. The thing about catalogs is they're free and once you order the first one you keep getting new ones every so often. But never a bill.

They're free, and once you order the first one you'll keep getting new ones.

Forty-Seventh Street Photo
Mail-Order Division
36 E. 19th Street
New York, N.Y. 10003

Executive Photo Supply
120 W. 31st Street
New York, N.Y. 10001

Retrieving Lost Film

If you rewind your film into the cassette by accident after partial use or before the roll is exposed, don't despair. One solution is to put the film into a chang-

ing bag and reinsert the spool into a reusable cassette. In such a case it is not necessary to rewind all the film on the new spool. Just pull the loaded spool from the commercial cassette and exchange it with the empty spool in a reloadable one.

Another technique is to cut a length of film in a wedge shape, put some double-sided tape on the inside, and slide it in the cassette opening. Once the film leader has made about half a revolution, turn the spool counterclockwise until it stops. This will press the two films together and then allow careful retrieval. Various commercial gadgets varying in utility and price are also available at your local photo dealer.

Free Advice on Cameras (and Women)

By selling a few shots you can cover the cost of your expenses and your expensive hobby will suddenly cost nothing.

An old girlfriend once told me the best things in life were free and then proceeded to prove her point with an affectionate kiss. I told her I was not convinced and she . . . pardon this interruption, but in the case of advice about 2¼ cameras the literature on medium-format cameras from Hasselblad is definitely the best and its by all means free. For your copies write to Hasselblad, 235 Main Street, Orange, New Jersey 07050. Now returning you to your sick sitcom; she slapped me.

Alarming Thieves

Losing photo equipment can cost you every penny you've saved by thrifty spending. The first precaution if you shoot in public places frequently is to stick a Bag Alert in your photo bag so you'll know

when it sprouts legs. When activated the device senses motion and sets off a burglar alarm that cannot be turned off by anyone other than the photographer. I suppose the theory is that you can follow the beeping and chase the thief through the crowds. The instruction booklet did not say what to do once you caught up with the thug. It sells for $29.95 through Argraph Corporation, 111 Asia Place, Carlstadt, New Jersey 07072.

Sellout

One way to save money is to spend a little. Specifically on a photographer's newsletter such as the *Photoletter*, or the *Photographer's Market Newsletter*, which help you sell your extra photos. By selling a few shots, which is "a cinch" according to both of these reports and most of their readers, you can cover the cost of your expenses and your expensive hobby will suddenly cost nothing. In fact, your photo sales may earn a substantial second income for you. Rohn Engh's *Photoletter* comes out every other week and is packed with requests from photo buyers across the nation. What's more, the back page usually is sprinkled with additional ways to cut costs on your photo expenses.

Here's one example: "For a copy of the book *Fifty Ways to Save Money on Your Postage*, please send $5 and a No. 10 self-addressed envelope to Nancy Olson, Daly Associates, 702 World Center Building, Washington, D.C. 20006."

For a copy of the *Photoletter* write Engh on your business letterhead in care of *Photoletter*, Osceola, Wisconsin 54020, and he'll send you a free copy (regular price $3.50).

And here is a way to save money on that. Should you decide to subscribe to this newsy news-

letter, mention my name and Engh will automatically give you a $20 discount.

The *Photographer's Market Newsletter* is published by the prestigious Writer's Digest book publishers and edited by the brilliant Bob Lutz. It is a monthly up-to-the-minute market guide listing hundreds of photo buyers that also includes helpful articles on how to sell your photos. Write to Lutz for a free sample copy of PMNL, Writer's Digest, 9933 Alliance Road, Cincinnati, Ohio 45242, and while you're at it ask why they call him the encyclopedist of the photo-marketing industry.

Mention my name and he'll either hang up or give you a $20 discount.

A Bunch More

And while we're onto newsletters, here are a few more that may help on one level or another of saving and spending:

APIdea
21822 Sherman Way
Canoga Park, California 91303

Photographically Speaking
1071 Wisconsin Avenue, N.W.
Washington, D.C. 20007

Photography Today
Route 2, Box 197
West Highway 46
Templeton, California 93465

Phototraveler
Box 8801
Toledo, Ohio 43623

Photo Market Newsletter
1500 Cardinal Drive
Little Falls, New Jersey 07424

Journal of American Photography
890 Supreme Drive
Bensenville, Illinois 60106

San Diego Photographer
348 W. Market Street, Suite 404
San Diego, California 92101

Freelancer's Newsletter
307 Westlake Drive
Austin, Texas 78746

Nikon Professional Services Newsletter
623 Stewart Avenue
Garden City, New York 11530

Turn a few clothespins inside out for a superb set of print tongs. Cost: three cents apiece, or less if you steal them from the laundry room.

Risk-Free

Whether you have a use for an alarm or not, you'd better make use of an insurance policy on all your equipment. Without any statistics to back myself up I would guess 8.532 percent of all stolen camera equipment is pilfered outside the home, so I carry a separate policy on camera equipment. Then whether the equipment is stolen or broken I don't have to pay for it. Here is a story all consumers will cherish: Once when a dune buggy ran into me at full tilt it shattered two brand-new Nikon F3s with motors and expensive lenses. I had taken out a new insurance policy two weeks before and so felt a bit dubious when I turned in a claim of $2,300 to my agent the following Thursday afternoon. The insurance company was located in downstate Illinois. Saturday (that's a day and a half later) a check arrived for the full amount, no questions. I didn't even think the mail traveled that fast. Monday the adjuster called to find out if I was okay. So it pays and it saves to have an insurance policy, and here's the one that treated me right: Pekin Insurance, 2505 Court Street, Pekin, Illinois 61558.

A day and a half later a check arrived for $2,300— no questions.

Photography Magazine Index

I consider anything that can stretch value to be cost-effective. Like the *Photography Magazine Index*, for instance, that can revive those useless photography magazines lying around the house. Essentially it categorizes all the articles that have appeared in nine major photo magazines for the past five years into a single index. If you remember an article you read but could never find it, now you can. Or pick a topic of interest and find all that's been published

on it. The magazines included are *American Photographer*, *Camera Arts*, *Camera 35*, *Darkroom Photography*, *Modern Photography*, *Petersen's Photography*, *Popular Photography*, and *The Rangefinder*. Send $8.20 to Paragon Publishing, Box 53, Santa Rosa, California 95402.

Curse of the Magic Touch

Spotone works fine and all that, but its curse is that you have to buy all three bottles when you only need, want, or use the middle one. That's what you think (it's what I thought all those years too). But it turns out the culprit is not the manufacturer but the imbecile dealers who only order the sets. Order single bottles of No. 3 Spotone for 75 cents directly from Retouch Methods, Box 345, Chatham, New Jersey 07928.

Cheap Reads

Ever need to fill out your magazine collection or photography book library but don't feel like trading a month's salary for it? Try shopping at the local used bookshops, which with the current burgeoning photo book production have begun to carry more and more photography titles.

Free Ad

Here's what it said: "Our ad agency told us that if we offered you something for nothing (a freebie)

not only would you be more likely to read this but
we might have a pretty fair shot at doing some busi-
ness with you. We think they're right. So let's make
a deal. Write to us at Graphik Dimensions Ltd., 41-
06 De Long Street, Flushing, New York 11355 and
two things will happen. 1. You'll receive a 40-page
full-color catalog listing 74 kinds of picture frames
(and other photo decor products. No big deal,
but . . .) 2. You'll receive a $5 gift certificate."
Well, that's worth at least one free frame.

 And if it's the catalogs you're after here's an-
other one. More or less. The Focal Press catalog
describes more than 100 photography and audiovi-
sual books. Focal Press, 10 Tower Office Park, Wo-
burn, Massachusetts 01801.

Free Consultation

There are dozens of government agencies that han-
dle technical information relating to photography.
You can call any of them free, or write for a free
guide listing all toll-free numbers: *Hotlines*, Public
Citizen, Box 19494, Washington, D.C. 20036.

Homemade Ground Glass

Ground glass is by no means inexpensive, but it can
be if you varnish it yourself. Mix these in order: ten
grams of sandarac and 2.25 grams of mastic in 100cc
ether and add 25 to 75cc benzol (the more benzol
the greater the matte effect). Paint this goop on any
piece of glass and it will turn opaque.

Just Hot Air

The first time you hear about making a soft-focus filter by smearing petroleum jelly on a clear filter it sounds like a terrific idea. Until you try it, or try to remove it. So then you decide it would be smarter to cut out pieces of clear plastic and then toss them like Pampers when you finish shooting. Well, here's something brighter yet: Use Gel-Clean, made for cleaning contact lenses. You get the same effect, but it rinses off in water and cleans the filter in the process.

You can even fog the lens with breath, but you have to shoot fast before it evaporates. The clean up is easy. All you have to do is nothing.

Dodging the IRS

In case you missed the section earlier or didn't feel like spending, at least order this freebie, "Tax Guide for Freelancers" from the Internal Revenue Service, Code 410, 1100 Commerce Street, Dallas, Texas 75242. It could save you more than taxes.

Wising Up for Nothing

When trying to buy the best lens for the least money, consumers are often boggled by the truckloads of technical information published about each lens. Kiron Corporation offers tech sheets that decode the NTF statistics and show the average layman

how to read technical data for judging lenses. Examples of their reports are "How to Read an NTF Curve Without Feeling Like a Bozo," and "What Mother Never Told You About Teleconverters." Copies of the Kiron tech sheets are available free from Kiron Corporation, 730 E. King's Hill Place, Carson, California 90746.

Contact Sheets Pretty Cheap

Remember when we talked about making Cibachrome contact sheets of your slides? C'mon, where were you? It was only a couple of pages ago. Anyway, if you don't have the equipment or energy to make your own, Solor Color will print them for $7.50 apiece, or for $5 each on an order of ten or more. Write to Solar Color at Box 69279, Los Angeles, California 90069.

New Polaroid Film for Less

Comparison evaluations are mandatory for all but the most impulsive buyers.

If you're still using Polaroid's Polarcolor ER sheet film, you must not know about the Polarcolor ER-type 559 Landpak film that's less expensive and comes in an eight-exposure pack rather than the single sheets. Order from your dealer or write to Polaroid at 575 Technology Square, Cambridge, Massachusetts 02139.

Trouble-Shooting With Tape

When you have a problem with one of your cameras and don't know which one is the culprit, place

a small piece of duct tape on the inside frame opening just behind the shutter curtain. This tape will not interfere with film passage, but will show up as a small pointer on one side of your frame. Some photographers like to file notches along one side of their shutter frame opening so they can easily identify from which camera the errant film comes.

Comparison Shopping

Don't buy photo equipment just because you see it in the store window. Compare every product on the market by looking through the *Photography Buyers Guide*. This annual guide costs $2.95 and includes more than 160 pages of products, photographs, prices, comparison charts, as well as buying hints. Sometimes it costs a little to save a lot. Write to Box 640, Holmes, Pennsylvania 19043. Other helpful guides include *Modern Photography*'s *Photo Information Almanac*, as well as their annual buying guides and the various consumer guide reports. With new camera models appearing nearly hourly, it seems, comparison evaluations are mandatory for all but the most impulsive buyers.

So it pays and it saves and it's nearly free.

Do-It-Yourself Guides

Embee Press at 82 Pine Grove, Kingston, New York 12401, offers books and guides to nearly every craft of photography. Some of the titles in their Photo Craft series include: "How to Adapt Old Lenses to Modern SLR Cameras," "How to Construct a Process Camera," "How to Recover Silver from Your Fixer," "How to Start a Photography Sell and Swap Shop," and "An Easy Way to Make

Giant Enlargements." Each guide sells for $3.50, and when you buy seven or more, Embee will assemble them into one custom book of guides.

Photographer's Market Under Cost

If you market your photographs and make use of the annual *Photographer's Market*, which lists more than 3,000 photo buyers and is updated annually, you can buy it at a 60 percent discount for only $4.98 through Barnes & Noble, Department 620, 126 Fifth Avenue, New York, New York 10011.

Conning the Con Artists

Ground glass is by no means inexpensive, but it is if you varnish it yourself.

Don't get taken by con-job photo offers. You've seen the ads in photography magazines that read "Will pay you $300 for every ten rolls of film you shoot," or, "Photos wanted for publications — send for free report," and so forth. Most of these offers require you to buy their full report for a larger sum of money and then ask for a participation cost at even more, which in the end reveals little. But just the same you think "What if there is something to this one?" You can find out without paying for their services. Rohn Engh, publisher of the *Photoletter* mentioned earlier, sends away for all these reports, pays for their services, and then tells you exactly what they offer periodically in his newsletter. *Photoletter*, Osceola, Wisconsin 54020.

Or if you don't want to wait, cut out the ad, send it to *Photographer's Market Newsletter*, 9933 Alliance Road, Cincinnati, Ohio 45242. Straightaway Editor Bob Lutz, who is always eager

to expose counterfeits, will order everything and then tell everyone via the newsletter what he received. Don't risk your money — let Lutz.

Demos for Half Price

Calument Photographic Industries has large quantities of new camera and photographic euipment used for demonstration which they're willing to sell for a fraction of the new price — with full warranty. An example is a Kodak Technographic RA-960 projector that normally sells for $1,129, on sale at the time of this writing for $495. Prices and items fluctuate, so call them toll-free at 800/323-2849.

It turns out the culprit is not the manufacturer but the embecile dealers.

When you need a giant light table, be prepared to spend a whopping fortune. Or else tape your slide pages to a picture window.

Oops!

When you accidentally open the back of your camera — and don't tell me you haven't — to find a roll of exposed film still in the works, fret not. Simply close the back of the camera, rewind the film back into its cassette and process it. Normally about three to four pictures — less if it is at the end of a roll — are all you will lose because the film shields the rest of the frames rolled on the take-up spool.

Free List of Free Booklets

One of the largest sources of sound photographic advice comes from Eastman Kodak's publishing department. A free book called *The Communicator's Catalogue* lists all the literature Kodak has available. For a copy write to Eastman Kodak Company, 343 State Street, Department 412L, Rochester, New York 14650, and ask for Kodak Publication S-4. And as long as you're using a stamp, also ask for the free publication 412-L, which lists among many varied titles, all the other free publications.

The End of the End

That's about all I can think of, except one more: If you come up with anything I didn't, let me know. I'll swap it for a free copy of the next edition, guaranteed to be obese. That's the ultimate cost-cutting tip — to get a book full of them without even paying for the book.

Notes from the Readers (About the Author)

"Before I order three more copies of your fine, fine, superfine book . . . "

J. F., New York, New York

"You're the greatest. The greatest bull-slinger, that is."

F. C., Chicago, Illinois

"The 'unorganized' format is refreshing."

J. W., New Wilmington, Pennsylvania

"This better be good . . . spending $8.95 isn't a very good start on cutting costs."

M. E., Wilmington, Delaware

"Evidently the 219th way for me to save money should have been in not purchasing this book."

J. M., New York, New York

"This is my second order — a splendid book."

A. S., Butte, Montana

"The book is a big fat mess! How about an index next time?"

R. S., Newark, New Jersey

Index

B

Batteries, discount prices, 84; five year, 83; decoding, 3; extending life of, 78, 81; reusable, 80; silver oxide, 83

C

Cameras, disposable, 14; modifications, 139; protection, 89, 92, 97, 148, 149; resale, 88, 66. *See also* Equipment.
Camera packs, 142
Chemicals, custom-ordered, 51; powdered, 123; stain removal, 119; storage, 107, 132; supermarket substitutes, 110
Chrome plating, 91
Club discounts, 46
Cibachrome prints, 51
Clamps, 7
Color correction, 121
Contact prints, 52, 176
Custom gear, 139, 148

D

Darkroom, construction, 109, 117; portable, 122; tips, 113, 114, 115, 119, 120
Developing, bulk quantities, 6; cheap developers, 125
Dupes, 49, 50, 162, 163
Dust control, 2, 117, 159

E

Energy conservation, 3, 13
Enlargements, free, 48
Enlarger conversions, 118, 124
Equipment, blue book, 66; confiscated, 9; demo, 179; rental, 70, 73; mail-order 58-62; used, 11, 63-66

Exakta, 159
Extension cords, 138

F

Film, bulk discounts, 25-26, 28; bulk loading, 24; cassettes, 26-27; double loading, 6; best prices, 16; home color processing, 129; free, 32, 134; Polaroid, 176; slides vs. negatives, 30
Filters, 157-158; best prices, 20; filing system, 12; large format, 20

G

Ground glass, 174

I

Insurance, 172

K

Kodachrome, best prices, 35; push-processing, 48
Kodak, processing mailers, 35, 47

L

Lens, carrying systems, 144; rental, 65, 71; repair, 102; reversing adaptor, 140; tissue, 4
Light meter, 8
Light tables, 5, 159

M

Mail, free express service, 43; reducing costs, 169
Masking materials, 17
Mount board, 2

N

Negative conversion, 33
Newsletters, 170

P

Paper, buying outdated, 19
Photofinishing, club discounts, 44; large format, 18, 118; lowest prices, 41, 42, 51, 52
Photographer's Market, 178
Photography Magazine Index, 172
Photo-murals, 113
Polaroid backs, 140
Print dryer, 125

R

Reflection screens, 7
Remote triggering, 145
Rental companies, 73, 74
Repair, how-to manuals, 98, 102, 177; lowest prices, 98; trouble-shooting, 94, 99, 100

S

Screens, rear-projection, 13
Shutter, repair, 101
Silver recovery, 11, 128
Special effects, 125
Spotting, 17
Squeegees, 14
Static control, 18
Synchronization unit, 161

T

Tax law, 160, 161, 175
Technical information, national hotline, 174; publications, 175
Telephone, reducing costs, 12; toll-free numbers 19
Temperature control, 110
Theft prevention, 168
Tongs, 158
Trades and exchanges, 16

U

Umbrellas, studio, 2

V

Vacuum, 93

Directory of Companies

A

Adorama, 35
Agfa-Gevaert, 125
Amoco Merchandise Center, 3
Arga Photo, 131
Argraph Corporation, 109

B

Beattie Systems, 156
Bennett Camera Exchange, 62

C

Calument Photographic Industries, 179
Camera Clinic, 67
Camera Traders Limited, 63
Camera World, 84
Chrome-Tone, 91
Cook's Custom Sewing, 143
Comcorps, 50
Craftsman Color Labs, 52
Creative Color, 50
Cybex, 124

D

Darkroom Aids, 10
D & I Camera Shoppe, 33
Duracell, 83
Duro, 101
Dynacolor Labs, 48

E

Eastman Kodak, 180
Eldee Sales, 27
Essex Camera, 98
Eveready, 84
Executive Photo Supply, 167

F

f/22 Press, 124
Fairstryk, 29
Fast Foto, 41
Focal Press, 174
Focus Electronics, 36
Forty-Seventh Street Photo, 36, 167

G

Gamma, 41
Garden Camera, 36
G-B Color Lab, 51
General Color, 42
Graphik Dimensions, 174

H

Hanimex, 14
Hasselblad, 168
Helix, 128

I

Internegatives, 49
Instant Image Film, 34

J

Jack's Loan, 62
JMAPCO, 35

K

KEH Camera Brokers, 62
Kiron Corporation, 175

L Laser Color, 49
Light Impressions, 2
Lion Photo, 10, 15, 32

M

Maxwell Photo-Mural Tanks, 114
Marron-Carrel, 164
Mini-Vac, 93
MSI Heritage Color Labs, 32
Myron Wolf Photographic Memorabilia, 66

O

Olden, 61
Optivision, 18
Phillips Process Company, 126
Photographer's Formulary, 51
Photo Imports, 63
Photographic Equipment, 123
Poly Paks, 151
Professional Camera Repair, 139

R
Retouch Methods, 173

S
SBI Research, 8
Seattle Film Works, 33
Sharp Photo, 36
Shutterbug Ads, 11, 32, 67, 165
SolarColor, 52
Special Products Labs, 122

T
Tiffen, 125
Toco Color Labs, 41

U
Unicolor Division Photo Systems, 129
Unity Buying Service, 62

V
Volunteer Lawyers for the Arts, 5

WoogCell, 128

Z
Zone V, 123

OTHER BOOKS BY ROBERT McQUILKIN
AVAILABLE THROUGH MCI

OUTDOOR PHOTOGRAPHY:
How to Shoot It, How to Sell It

A guide to every outdoor market ● A unique submission technique that rarely fails ● The five big markets and how to enter them ● Essential steps to publishing ● The ten commandments of submitting by mail ● Achieving a high rate of sales that is self-perpetuating ● What not to send—what editors hate most ● How to get a quick answer from any buyer ● How to sell your photographs as art ● When to use an agent or stock house (and some warnings) ● Advice from three magazine editors ● How to stretch your camera's warranty ● Shoot to sell ● Photo foul-ups and how to avoid them ● Functioning in extreme weather

"One of the best books of its kind I've ever read. **Outdoor Photography: How to Shoot it, How to Sell It** is packed with solid advice and information drawn directly from author Robert McQuilkin's years of professional photographic experience."
—Bill Baughman
The Cleveland Press

"McQuilkin's style is breezy as he concentrates on photographing wildlife (it takes a lot of patience), wilderness, scenery, outdoor sports and closeup details of nature. The second portion of the book covers selling in 'the five big markets' and how to approach buyers."
—Lou Jacobs, Jr.
The New York Times

"What may justify your interest in this book are McQuilkin's first-hand observations and experimental hints. Reading McQuilkin's book or adhering to the professional advice of Tallon or Rowell is certainly no guarantee of success in outdoor photography. That comes only from interest in the outdoor world, talent, technical proficiency, guts, determination, patience, intelligence, hard work, inspiration, experimentation, artistic feeling, and the desire to communicate. But this book may serve to launch you into an area of photography with many outlets for your work and the ability to bring your outdoorsy fantasies to fruition."
—Howard Chapnick
Popular Photography

A MacMillan Book Club selection
Carried by the Photographic Book Society
Clothbound, 180 pages, 140 pictures, $14.95

HOW TO PHOTOGRAPH SPORTS AND ACTION

Choosing and using the right equipment
● Protection against the elements
● Professional focusing techniques ● Exploiting
the motor drive ● Controlling viewpoint and
background ● Unique compositions ● Helpful
hints for specific sports ● Calculated experi-
ments ● Freezing motion, panning and peak
action ● Remote-control photography ● Winter
photography ● Developing a photojournalistic
eye ● Portraits, storytelling and photojournalism
● Entering contests and winning ● Selling your
photos ● Finding and developing creativity

"An informative and often-entertaining book for those who want to
know secrets of the pros who get paid for making action photos come
alive. Award-winning outdoor photographer Robert McQuilkin gives
illustrated advice on everything from equipment to creativity."
— *The Christian Science Monitor*

"McQuilkin tells how to develop a quick-focus technique—shoot without
focusing at all, freeze the action, and get better color."
— *Petersen's Photographic*

"Excellent. The book is practically a lesson in photography, packed
with the author's tips, hints and guidelines, all based on personal
experience."
— *PSA Journal*

"Neophyte and professionals alike will appreciate McQuilkin's advice on
buying the proper equipment, using it and protecting it from the natural
elements and dangers of sports."
— *Outdoors Unlimited*

Paper, 160 pages, 300 color plates, $9.95

"An excellent guide for novice and expert
photographer alike on how to shoot almost any
self-propelled subject, including hiking, ca-
noeing, cycling, and skiing. It's an excellent
investment for anyone who owns any type of
camera."
— *Frank Ashley*
Syndicated columnist

Spiral bound, 208 pages, $11.95
Paper, $9.95

OUTDOOR SPORTS PHOTOGRAPHY BOOK

A candid appraisal of today's photo equipmen
which does and doesn't work for sports an
action ● The best options and accessorie
● Camera operation simplified ● Tips to avoi
trouble ● Extreme weather photograph
● Developing speed, accuracy, and efficiency t
stop action ● More mileage from your aut
● Decent exposure in lousy light ● Improvin
color ● Film choice ● Special technique fc
outdoor sports, including white water, mour
taineering, scuba diving, sky diving, sailin
● Learning to see differently

"How many times have you witnessed a
exciting sport and wished you had captured th
moment? Now journalist/photographer Robe
McQuilkin tells how..."
— *Runner's Wor*

THE PHOTO SEMINAR

Effective advertising ● The gift offer goes far ● Dynamic presentation ● Speaking hints ● What the public is most interested in ● Guest speakers add credence—where to find them ● How to keep current ● Variety adds spice ● Assignments that are appreciated ● The complete slide show ● Most-asked questions ● Problems to expect and avoid ● The power of being unique ● Selling out ● Evaluation: yours and theirs ● Accurate records save money ● Budgeting ● A ready-made photography course

f you are actively involved in presentation or aching or considering this field even on a nited basis, I highly recommend this book for s invaluable information."
—Photographic Society of America

lothbound, 134 pages, $12.95
aper, $9.95

"McQuilkin's book is directed toward professional photographers who are in a position to share their knowledge and experience with others; who would like to try teaching; who would not be adverse to adding to their income, but do not know how to go about it."
—Studio Photography

H O W T O O R D E R

Outdoor Photography: How to Shoot It, How to Sell It $14.95
How to Shoot Sports and Action .. 9.95
Outdoor Sports Photography Book
 Spiral bound .. 11.95
 Paper ... 9.95
How to Cut Photo Costs
 Clothbound ... 12.95
 Paper ... 8.95
The Photo Seminar
 Clothbound ... 12.95
 Paper ... 9.95

Mailing charge $1.50 for first book, $1 for each book thereafter.
Illinois residents add 5% sales tax

TOTAL ══════

Shipping address _____

MCI Publishing
P.O. Box 162
Winfield, IL 60191